THE
BEAUTIFUL
HISTORY

To Dad
(David 'Charlie' Routledge)

Happy 80th Birthday

CONTENTS

PRE-HISTORY

THE ROMANS

CHRISTIANS, VIKINGS AND SAXONS

THE NORMANS

THE TUDORS AND STUARTS

THE GEORGIANS

THE VICTORIANS AND BEYOND

THE WORLD WARS

RECENT TIMES

TIME ADDED ON

INTRODUCTION

1938

Have you ever noticed how the badges of football clubs up and down the country, help to tell the story of these islands?

From Stirling Albion's William 'Braveheart' Wallace to Hemel Hempstead FC's Henry VIII, many clubs celebrate a famous character from history. Others have honoured a past or present industry which has drawn fans from its workforce – mining, textiles, fishing, transport to name but a few. Some badges are associated with more unusual industries – straw boaters with Luton Town or brewing with Burton Albion.

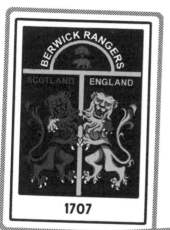

1707

Centuries later some clubs still display their loyalty to the two sides battling for the throne of England in the Wars of the Roses. Displaying a red rose means support for the House of Lancaster while a white rose stands for the House of York. Bringing the story into the digital age, do you know which club features an enormous hashtag on its badge?

The identity of the club, expressed through its badge, is everywhere – on computer and TV screens,

450 AD

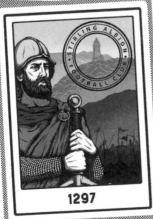

1297

1054

1817

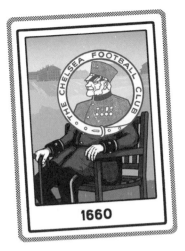

1660

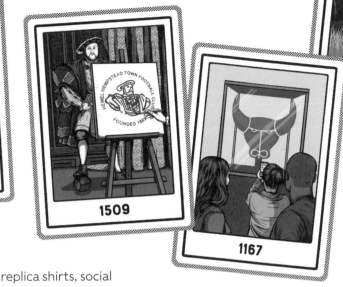

1509

1167

1263

1761

replica shirts, social media and stadia. You may recognise the red dragon, the imp and the cannon, but do you know the stories behind the badges, why a particular image was chosen and what it reflected about the home town. *The Beautiful History* is a new way of telling an age-old story, the history of Britain. Badges provide a surprising hook into momentous events such as the defeat of Napoleon or broad themes like slavery or poverty. Other badges feature local heroes like Skippy the Yorkshire terrier.

Just as football is a game of the people, so too the story of Britain is told with badges from all levels of the game. This is grass roots history not a Premier League version of events. Step inside the time machine of *A Beautiful History* and take a journey that has never been travelled before. You will meet some remarkable characters along the way.

1349

1894

FROM SHIELD TO SCREEN
IN 900 YEARS

Most people are familiar with coats of arms from their school badge, the tombs of great lords and ladies or the letterhead used by their local council. Many football badges are based on the coat of arms of the place where their home ground is. While a few football clubs have simply copied the town arms, many have made it simpler or more appropriate to football over the years. Using the town crest gives fans a sense of pride in place and of their long heritage. Think of some of the biggest teams in England like the two top Manchester clubs. Both club's badges are based on the city's coat of arms.

The story of the coat of arms goes back to Norman knights, the super-stars of their day. They fought on horseback holding a long spear or lance under their arm and ramming it into the enemy at speed before finishing him off with a sword or a club. Their horses were bred to be war machines. To protect themselves knights wore armour and carried

12TH CENTURY

A knight on the battlefield

Members of the same family increasingly chose the same colours and patterns like this diamond known as a lozenge, and the cross, known as a cross crosslet.

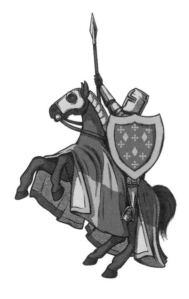

15TH-19TH CENTURIES

A display of civic pride

From small towns to big cities throughout Britain, coats of arms can be spotted on commercial and public buildings. This example comes from Stockport.

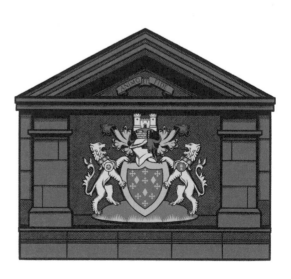

shields. There was one problem. How could you tell friend from enemy in the dust of battle if he hid his face under a helmet? The solution was to mark his shield or flag with a design used only by his family. A bold symbol helped at a time when many people could not read nor write.

Over the centuries coats of arms became more complex and associated with important local families. Heraldry developed its own language and rules. In the centre is the shield, often divided into quarters. Technically the crest is the top part of the arms, often sitting on a helmet. The creatures or objects at the sides of the shield are the supporters. The lion, king of beasts, is the most popular animal although some crests are supported by mythical beasts like loggerheads or unicorns. Many coats of arms have a motto, usually in Latin, inscribed on a ribbon at the top or foot. In football talk the 'crest' is often used to describe the whole coat of arms.

20TH CENTURY

Football club badge

What did Stockport County FC add to the town coat of arms to create their football badge?

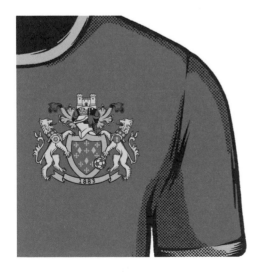

21ST CENTURY

Badge or brand?

In the digital age, the badge is just part of a club's 'brand' or visual identity. Stockport County use simple heraldic elements from their badge that supporters recognise. They are used, for example, on social media to announce a goal. The word may flash on and off for added effect. This need for simple graphic shapes, such as the lozenge and the cross crosslet takes us back nearly 1,000 years to the early days of heraldry.

Having a town coat of arms became very popular in the 19th and 20th centuries. It was a sign that a town had 'made it'.

The town coat of arms was also adopted by schools, other sports clubs and even the local regiment. The arms displayed symbols from local landowning families or from major industries. Most football clubs adopted them at some point in their history even if only for high profile matches like cup finals.

Recognising the importance of history to their fans, clubs like Blackpool FC have returned to basing their badge on the town's coat of arms. Some clubs, such as Brentford, have recently gone in the other direction and simplified their badge, stating the need for it to be easily displayed on the small screen of a smartphone, and across social media.

CHOOSE YOUR COLOUR

The colours each meant a different quality.
Red was for boldness and blue for loyalty.

Sable
(black) = wisdom

Purpure
(purple) = royal

Gules
(red) = boldness

Or
(gold) = glory

Azure
(blue) = strength

Argent
(silver or white) = peace

Vert
(green) = hope

COAT OF ARMS

Crest – the part
above the helm

Motto

Helm or
helmet

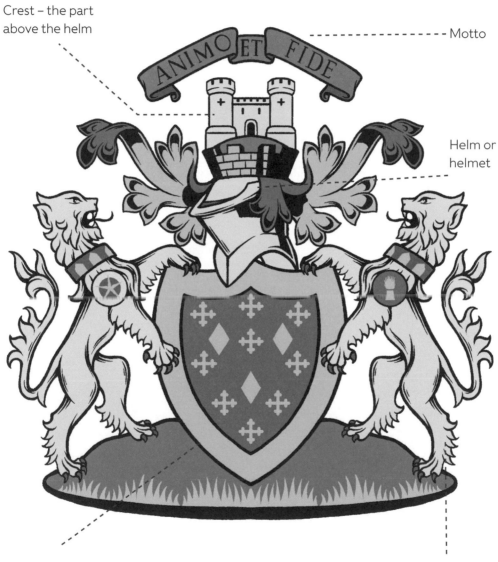

Shield – The shape changed
over the centuries

Supporters

PRE-HISTORY

I AM A DINOSAUR, AN ABSOLUTE DINOSAUR.

BUT WHAT I AM? I AM A WINNER!

SIR ALEX FERGUSON
ON MANCHESTER UNITED LOSING THE 2011/12 SEASON TITLE TO MANCHESTER CITY

THE VOLCANO AND THE ELEPHANT

Volcanoes erupted in many parts of Britain around 330 million years ago.

A volcano is created when a crack develops in the surface of the Earth. Ash, boiling rock and gases pour out from deep inside. When this material reaches the surface, it is called lava which, when it cools, hardens into rock like basalt.

Dumbarton Rock on Scotland's Clyde estuary was once a volcano. All that remains is the basalt plug at its root. This plug filled with lava, forming a harder material than the surrounding rock which was then worn away by weather and ice over many centuries. The Rock itself has been worn into a smoother, rounder shape by the melting sheets of ice which covered it during the Ice Ages. Glaciers rubbed the rock faces smooth like a scouring pad.

People have defended the Rock since earliest times. It has the longest recorded history of any British stronghold. William Wallace, Mary Queen of Scots, William Wordsworth – they all climbed the Rock.

So what is the connection between a volcano and the elephant featured on the badge of Dumbarton FC? The answer is simple. The Rock's shape reminded people of an elephant, and so it became the symbol of the town. The home ground of Dumbarton FC sits directly below, and unsurprisingly, is commonly known as 'The Rock'.

PANGAEA
Britain at the time was part of one super-continent, Pangaea.

DID YOU KNOW? The first modern elephant to set foot on British soil was probably brought over when the Romans invaded although there were elephants with straight tusks in prehistoric times.

WHY NOT? Climb one of Britain's extinct volcanoes – Ben Nevis, Snowdon, the Borrowdale Hills in the Lake District, Edinburgh Castle.

VISIT The royal stronghold and military fort of Dumbarton Castle on the Rock.

SPOT THE DIFFERENCE

Do you think that Dumbarton Rock looks like an elephant?

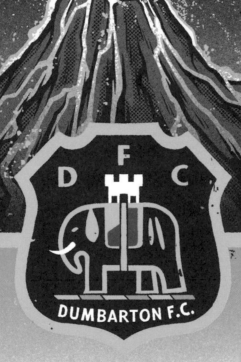

DUMBARTON F.C.

200 MILLION YEARS AGO
ALL CREATURES GREAT AND SMALL

Over many millions of years, the land that we call Britain has been on the move. The climate has switched regularly from desert-like hot and dry to icy cold.

Twenty-one different sorts of dinosaurs lived in England when it was a group of tropical islands near the Equator. The largest were members of the sauropod family with tiny heads and bodies as long as two buses.

Not everything was gigantic. 200 million years ago ammonites, distant relatives of today's squid, with spiral shells, swam in the warm seas off Britain. Their shells varied in size from a few centimetres to that of a bicycle wheel. Fossils tell us what the shells looked like but we can only guess at the soft bodies inside. There were lots of fish in the sea as well as giant marine reptiles.

Fossils are our only clue as to what dinosaurs lived in Britain's Jurassic Park. Like detectives, scientists piece together an animal's lifestyle from tiny pieces of evidence that have hardened into stone – a leg bone, a tooth, a pile of poo.

Like many other living things, the dinosaurs died out 65 million years ago when a giant ball of rock crashed into our planet.

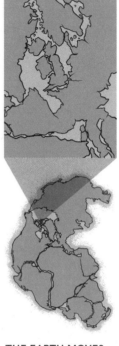

THE EARTH MOVES
Pangaea was starting to break up. Can you see the shapes of countries and new continents that were beginning to form?

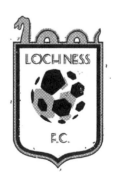

LOCH NESS FC
Some people believe that Nessie, the legendary monster, is a survivor of the plesiosaurs, large marine reptiles with very long necks!

DID YOU KNOW? Whitby Town FC has three ammonite fossils on its badge. Many ammonites are found on the nearby Yorkshire coast. Some are smaller than a referee's red card.

WHY NOT? Look out for a pigeon? Birds are distant relatives of dinosaurs.

VISIT Your local museum. It might have a bit of dinosaur among its fossils.

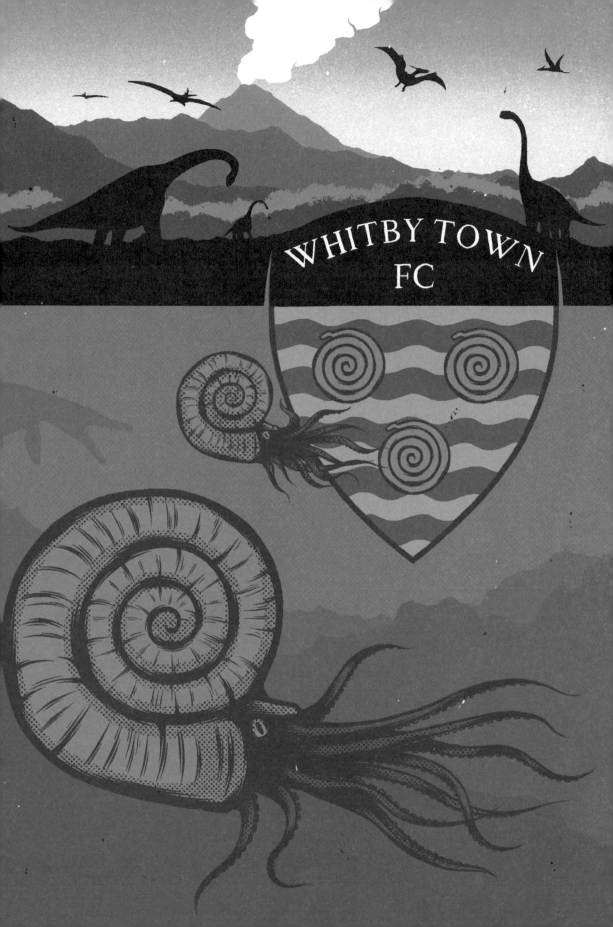

WHITBY TOWN FC

12,000BC
SETTLING DOWN

The first modern humans, the people that you are directly related to, arrived in Britain from Europe and stayed.

At first they camped largely near the coast around 12,000BC. They are called hunter-gatherers as the men mostly killed wild animals including young deer and caught fish while the women gathered fruit and nuts. They passed the time drawing and telling stories. When the food supply ran out they moved on. We know about their lifestyle from the rubbish they left behind – animal bones and seafood shells.

There are puzzles like the 36 deer skull headdresses found near the coast in Yorkshire. Were they worn as part of a ritual or to help in hunting? How did the hunters kill the deer? With arrows made of wood or thrown with a stick, or with the sharp point of a deer's antler?

We know a little about what these early people looked like by analysing the DNA of Cheddar Man who lived around 7,100BC. He is the oldest, nearly complete skeleton of a modern human found in Britain. His skin was quite dark, his hair was dark brown and his eyes were either green or blue. He was about 166cm (5ft 6in) tall, aged in his twenties and unable to digest milk.

Suddenly about 6,000BC, Britain was 'invaded' by the first farmers from Europe. Life was never the same again.

CONNECTED TO EUROPE

The first humans did not swim the Channel. Like animals before them they could walk as Britain was still connected to Europe by land. Doggerland was flooded by the rising ocean around 8,500BC.

WANDERING WOLVES

Wolves were one of the first animals to arrive in Britain. Packs of wolves followed the herds of deer, boar and grazing animals across Doggerland as they moved north.

DID YOU KNOW? The name Hartlepool derives from Old English heort meaning a hart or stag, and pōl the pool of water where it drank. That's why there's water on the Hartlepool FC badge.

WHY NOT? Look up the website for Lascaux in France, the most famous example of cave art in Europe.

VISIT Cresswell Crags in Derbyshire. The caves are home to one of the earliest examples of cave art in Britain.

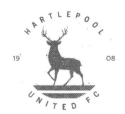

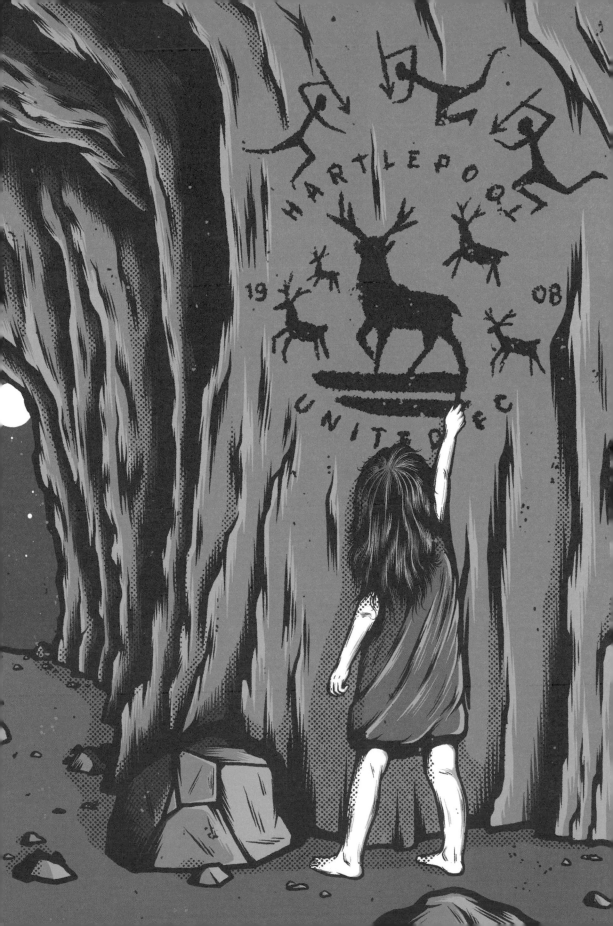

6,000BC
TAMING THE LAND

As the centuries passed, people had acquired new skills. They worked in stone, then metal like bronze and iron. They mined flint, tin and copper and traded overseas.

Animals had to watch out as weapons became more efficient. Houses and villages were built in the forests. People made clothes from animal skins and things like carvings and jewellery just for enjoyment.

They looked for new sources of natural resources and found them in the woodlands which covered much of Britain. The first farmers cut down the forests and used the land for crops and grazing animals. They tamed sheep and pigs and milked cows and goats; dogs became 'man's best friend'. Were the famous stone circles like Stonehenge places for farmers to meet, hold religious ceremonies, bury the dead or study the stars?

When the weather grew colder and wetter, people took to the hilltops, building forts with ditches and banks to keep rival tribes out. By 2,000 BC half of the area of Britain had been turned into farmland. Some patches of forest remained or were cut down for timber.

A few like Sherwood Forest in Nottinghamshire became royal forests after 1066, popular with kings for hunting. By 1200, the time of its most famous resident, the legendary Robin Hood, Sherwood Forest covered a fifth of Nottinghamshire.

Today Sherwood Forest is a national nature reserve and country park for everyone to enjoy.

It is celebrated in the name and badge of Nottingham Forest FC.

BRITAIN IS AN ISLAND
Doggerland had vanished under the waves. Britain was now an island, separate from Europe.

NOTTINGHAM FOREST
Local design lecturer, David Lewis, won the competition to come up with a badge for Nottingham Forest FC in 1973. His prize was £25.

DID YOU KNOW? A 'forest' was actually a legal term for an area under royal laws to protect game and timber. The laws were strictly policed and disliked by peasants who felt that they were robbed of their land.

WHY NOT? Play a game of dice, Britain's oldest pastime which our prehistoric ancestors enjoyed.

VISIT Find out if there was once a royal hunting forest near you. King Henry VIII hunted in what is now Regent's Park, in London.

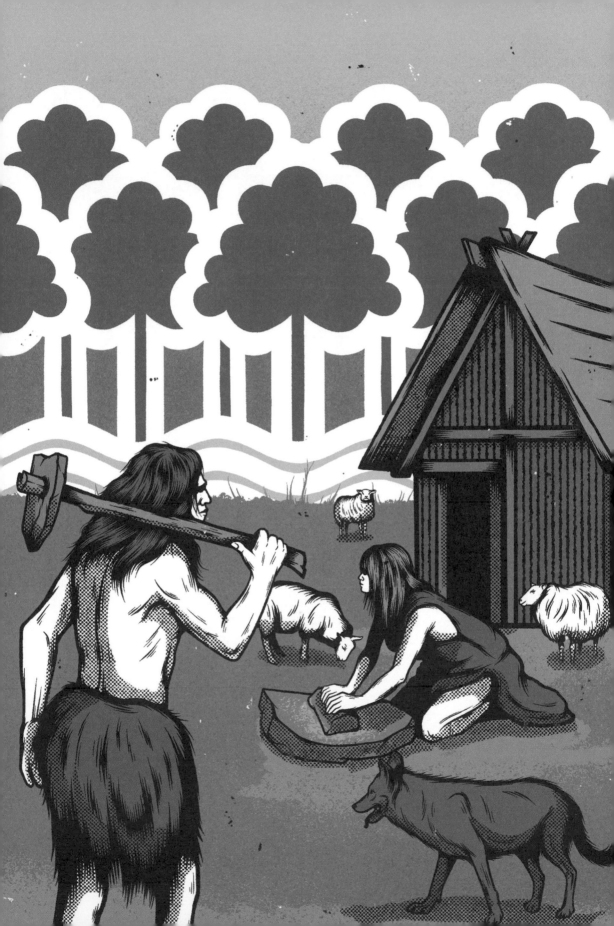

THE ROMANS

THEY SAY ROME WASN'T BUILT IN A DAY, BUT I WASN'T ON THAT PARTICULAR JOB.

BRIAN CLOUGH
MANAGER, NOTTINGHAM FOREST

55BC
VENI VIDI VICI

The Romans first came to Britain in 55BC. They liked what they saw. They stayed for hundreds of years.

They set up a camp for soldiers at Colchester in Essex. They called it Camulodunum - The 'Fortress of the War God Camulos'. It grew into a city and became the first capital of Britain. Warrior Queen Boudica burned Colchester to the ground around 60AD. The Romans rebuilt it, this time protecting it with walls.

There was plenty of fun for the citizens – more theatres than any other Roman town in Britain and the country's only sports arena which could seat 8,000 people, only 2,000 less than the town's football stadium today.

Here people were more likely to watch chariot races than football. The Romans did play the beautiful game but not as we know it. Called harpastum, it was more like rugby than football. Soldiers were encouraged to play to keep fit.

The eagle was popular with the Romans. The king of birds stood for power and Empire. When on the march the legion, the basic unit of the Roman army, carried a pole with an eagle on top. The Romans used the brand SPQR standing for Senatus Populusque Romanus, the Government and People of Rome.

Colchester United Football Club promotes its links with its past and has a Roman eagle on its badge.

A TOUGH OPPONENT
Boudica was Queen of the British Iceni tribe in East Anglia. Because she and her tribe had been mistreated, she was ready to take revenge against the might of the Roman army. Boudica lost many more men than the Romans, and rather than surrender, it is likely she swallowed poison.

DID YOU KNOW? Colchester, Chesterfield, Manchester. The Romans made their mark on place names by adding 'chester' from the Latin 'castrum' meaning 'camp' at the end.

WHY NOT? See how many places or football teams can you think of that feature the word 'chester'.

VISIT The Roman circus at Colchester, the site of Britain's only known chariot racetrack.

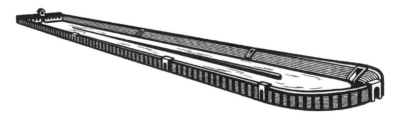

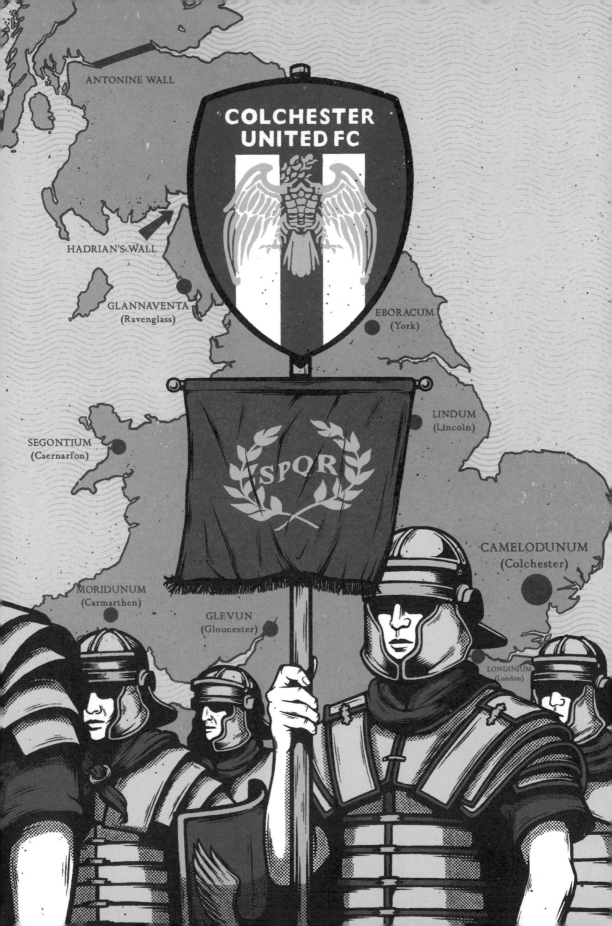

A RED FFYRY DRAGON

Visit Wales and you cannot miss seeing dragons.

These legendary beasts are on buildings, flags, the faces of rugby fans and of course football badges. Dragons have been popular in many cultures around the world including with Roman soldiers. The Welsh dragon has wings and can breathe fire.

When the Romans invaded, their native British neighbours often attacked them. In 410AD the Romans decided to leave, as their armies needed to defend other parts of their Empire. The Anglo-Saxons from Germany and Denmark moved into the south and east of the country. They pushed the native tribes into the hillier, less fertile lands like Wales. Wales was divided into several kingdoms and their warring leaders adopted the Welsh dragon to show their authority.

Writers imagined the early history of Wales. They told the story of warlord Vortigern who wanted to build a castle here, sometime before 450AD. A boy warned him that his chosen site lay above a lake where two dragons were sleeping. Castle workmen found a white and a red dragon fighting. The red dragon won. The boy may have been Merlin the magician at the court of King Arthur, predicting wrongly that the Welsh would beat the English in a great battle.

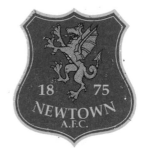

WELSH DRAGONS
The badges of the Football Association of Wales, Newtown AFC and Wrexham AFC are among the many in Wales that feature a dragon.

DID YOU KNOW? In 1958 dragons were waving when Wales reached the quarter-finals of the World Cup, before being eliminated by eventual winners, Brazil.

WHY NOT? Try saying 'Cymru am byth'? The motto means 'Wales forever'.

VISIT Wrexham County Borough Museum, which has the oldest surviving Welsh football badge dating from 1884.

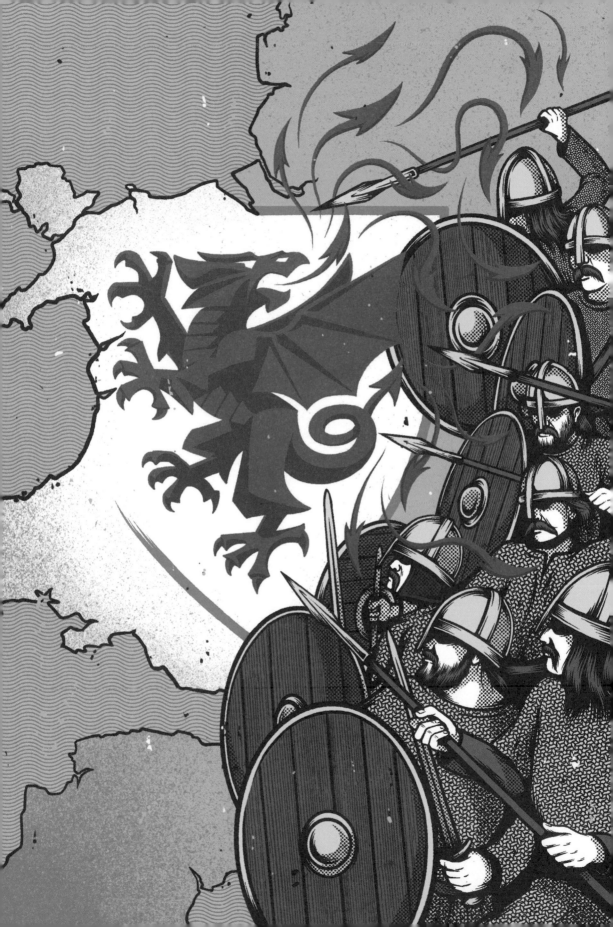

CHRISTIANS,
VIKINGS AND
SAXONS

A LITTLE WITH THE HEAD OF MARADONA AND A LITTLE WITH THE HAND OF GOD.

DIEGO MARADONA
EXPLAINING HIS GOAL AGAINST ENGLAND IN THE 1986 WORLD CUP QUARTER-FINAL

NOT ANGLES BUT ANGELS

The Anglo-Saxons worshipped many gods and often killed people who had become Christians in Roman times. In the 6th century AD, missionaries travelled the land to convert the Anglo-Saxons to Christianity.

St Columba sailed from Ireland to found a monastery on Iona off the west coast of Scotland and his followers spread the new religion to Northumbria. In 597AD Pope Gregory the Great sent Augustine to Britain. Augustine landed in Kent and was welcomed by the local pagan king, Æthelbert. His wife Bertha, a German princess was already Christian. Augustine became the first Archbishop of Canterbury and was soon worshipped as a saint.

By the end of the 7th century Anglo-Saxon England was a Christian country. Monasteries and parish churches spread over the land and early leaders and martyrs who died for their faith were made saints. Monks illustrated religious books like the Lindisfarne Gospels with paintings and gold leaf. Later, when towns wanted a crest, some chose to feature a local figure which is how some saints ended up on football badges.

Other towns chose symbols associated with the Bible after which the local parish church had been named – the Virgin Mary, St John the Baptist, a cross, or a sign of Jesus, the Lamb of God like Preston North End FC.

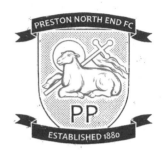

PROUD PRESTON
The letters 'PP' on Preston's badge are a bit of a mystery. Some people believe that they stand for 'Princeps Pacis' the Prince of Peace, another name for Jesus Christ. Others think they stand for 'Proud Preston'. Take your pick.

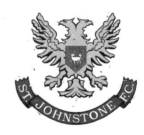

JOHN THE BAPTIST
The lamb at the centre of the St Johnstone badge belongs to a different saint. John the Baptist foretold the coming of the lamb of God. The old name for Perth in Scotland where St Johnstone play was 'St Johns ton.'

DID YOU KNOW? Several football clubs were founded by religious groups. They wanted to keep young boys off the streets and out of the pubs by giving them a healthy game to play. Clubs including Manchester City, Everton, Southampton, Bolton Wanderers, Celtic and Birmingham City all trace their origins in this way.

WHY NOT? Find out who your local church is named after and what the story is.

VISIT The Harris Art Gallery in Preston to see the portrait of the club's greatest ever player, Sir Tom Finney.

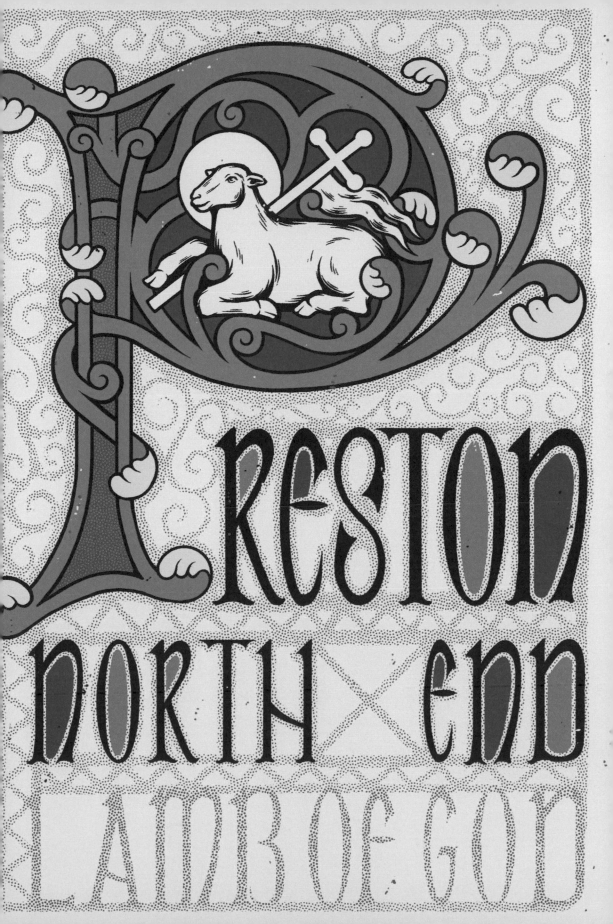

PRESTON NORTH END

LAMB OF GOD

VIKING RAIDERS FROM THE SEA

DONCASTER ROVERS
FC Yorkshire's Doncaster Rovers FC chose a Viking as a fearless warrior. The Vikings had made nearby York their capital.

One day in 793AD the monks of Lindisfarne off the Northumbrian coast were startled to see strange longships approaching.

Within hours their church was in flames, their treasures stolen and monks killed or captured. The event shocked Europe.

The first Viking raid on Britain was at the other end of the country four years earlier but this was different. It was fierce, sudden and struck at the heart of a Christian community. Raids on Britain continued, by the Norsemen from Norway along the coasts of Scotland and Ireland, and in the south and east by the Danes.

At first the raids took place in summer and the Vikings then returned home to their farms to harvest their crops. In the mid 860s AD they decided to stay, at first camping near their ships. Their wooden vessels were built for speed and could sail up rivers. No-one was safe. The Vikings travelled the world exploring and trading, even to distant lands like India and North America. They worshipped warlike gods.

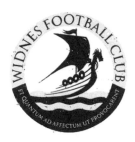

WIDNES FC
The town of Widnes in Lancashire is on the Mersey, the river that marked the boundary between the Viking Danelaw and the Anglo-Saxon kingdom of Mercia.

The last great Viking invasion was defeated near York in 1066 the same year as the Norman Conquest.

DID YOU KNOW? The Vikings, including women and children, enjoyed warlike sports like spear throwing and wrestling. All good practice for the real thing.

WHY NOT? Write the name of your team in the Viking alphabet called runes. Each letter was made up of straight lines and had magical powers.

VISIT The Jorvik Viking Centre in York, to experience the everyday sights, sounds and smells of a Viking community.

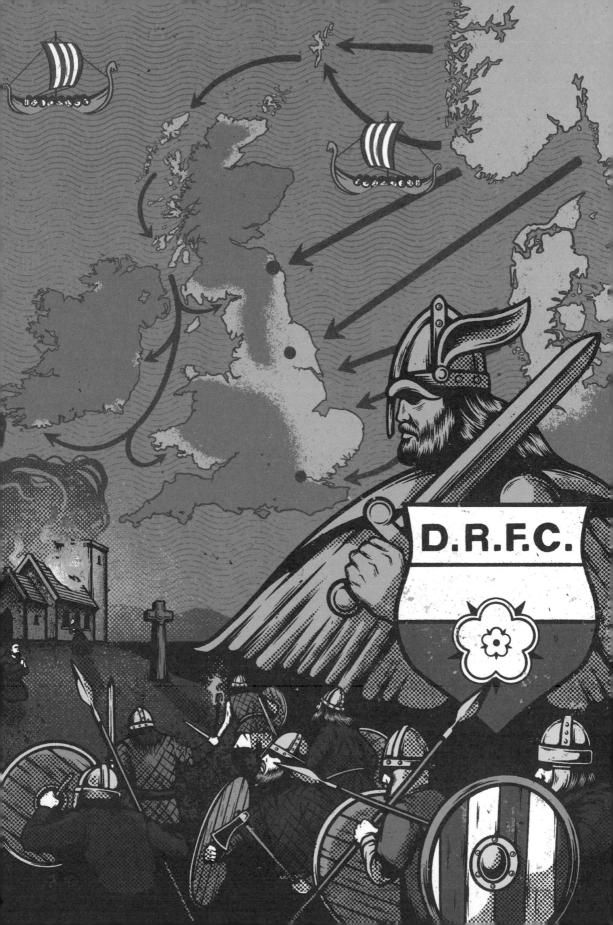

FLYING THE FLAG

The saltire, the national flag of Scotland, features on many football badges including that of the national team.

Its origins lie in a battle fought in Anglo-Saxon times, in 832AD.

At the time Britain was divided into many kingdoms. To the north of the powerful lands of Northumbria lay the territory of the Picts. The Romans called these Celtic tribes, the painted ones. This mysterious tribe left behind beautifully carved stones. They merged with their western neighbours, the Scots, to make Scotland.

In 832AD an army of Picts and Scots raided Northumbria. A much larger Anglo-Saxon army chased them back, meeting at Athelstaneford in the clash of battle. Fearing that they would lose the battle the king of the Picts led his troops in prayer. A white cloud appeared in the blue sky in the shape of an X, the cross on which Andrew, one of Jesus's followers, had been put to death.

This shape of cross is known as a saltire. The king promised that if the saint helped him win the battle, Andrew would be made the special saint of Scotland. The Scots won. The Saltire became the flag of the new country and St Andrew its patron saint.

WHAT DOES IT MEAN? A stone carved by the Picts with their distinctive symbols, that you can still see today, Aberlemno, Angus.

DID YOU KNOW? Saint Andrew is unlikely ever to have set foot in Scotland.

WHY NOT? Find out how many Scottish clubs feature the saltire in their badge, like Ayr United, whose badge was designed by fan Jamie Stevenson in a competition set by the club.

VISIT The National Flag Heritage Centre at the village of Athelstaneford in East Lothian.

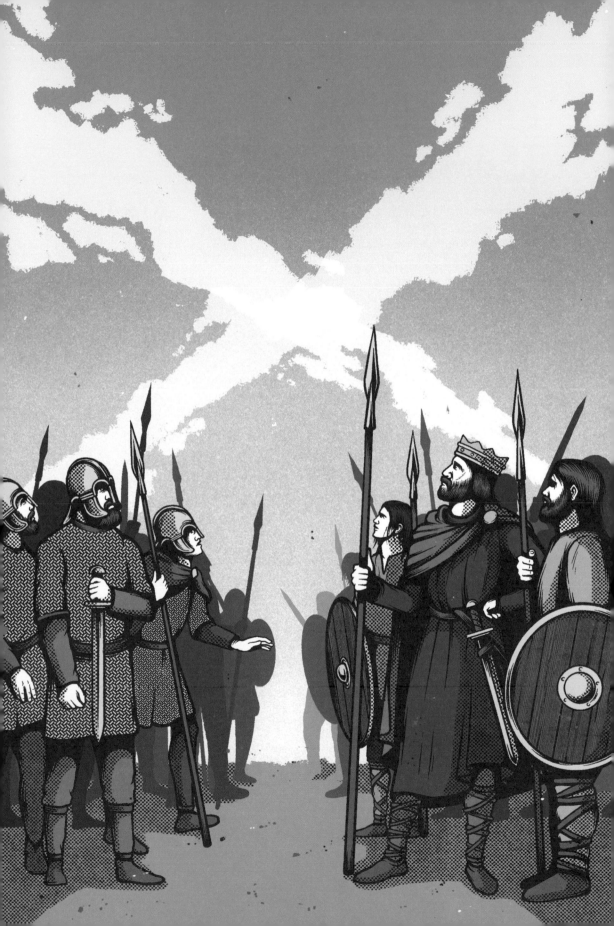

886AD
GREAT KING, TERRIBLE COOK

The Anglo-Saxon period saw many shifts in the boundaries of different kingdoms depending on whose leader was the most powerful.

There was no country called England. Alfred the Great was king of Wessex in the west when the Danes attacked his lands. Their population had expanded and they were looking for new places to settle.

For many years Alfred fought against the Danes and their warlord, Guthrum. Alfred won some battles and lost others. While in hiding after losing one fight, it is said that he sheltered in the house of a woman who asked him to watch her cakes. Alfred was so busy thinking about his kingdom that he let the cakes burn. Because he was in disguise she did not recognise him and told him off.

In 886AD Alfred and Guthrum made peace. They divided the land between them. Guthrum controlled the east and middle of the country known as the Danelaw with its own laws and coins. Guthrum became a Christian and agreed to leave Wessex which was never attacked by the Danes again.

Alfred's grandson, Athelstan, became the first king of England.

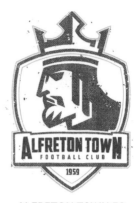

ALFRETON TOWN FC
Alfreton in Derbyshire is said to have been founded by Alfred the Great. He is commemorated in many places around the town, including the badge of Alfreton Town FC.

DID YOU KNOW? A large part of what is now England was under Danelaw. Look at the map to see if where you live was part of the Danelaw.

WHY NOT? Bake some cakes but remember not to burn them. They would have tasted like oatcakes or scones with no sugar.

VISIT The town nearest you that ends in 'ton'. That means that it was once in Anglo-Saxon hands as 'ton' is Old English for a farmstead or village.

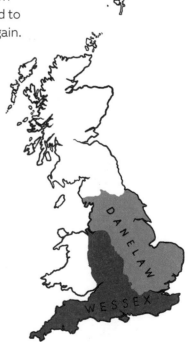

WHERE SHALL WE THREE MEET AGAIN?

Why let facts get in the way of a good story? The 16th century playwright, William Shakespeare, was one of the best, gripping audiences with plays like Macbeth ...

The real Macbeth was an 11th century Scottish king. His father was murdered during a family quarrel. Macbeth wanted revenge. He burned alive his cousin and married his wife. Macbeth killed the real King Duncan in battle or had him murdered. Duncan's son, Malcolm Canmore fled with his uncle Siward, Earl of Northumbria.

Now king of Scotland, Macbeth ruled the country well. He did a deal with the Vikings to bring peace and gave money to charity.

Malcolm and Siward marched into Scotland at the head of an army, killing and plundering as they went. According to tradition they defeated Macbeth at Dunsinane Hill. He escaped, but three years later was found and killed. As the new king, Malcolm Canmore kept a firm grip on Scotland.

The witches, the murder of Duncan in Macbeth's guest bedroom, the trees that moved to hide Malcolm's army – all were dreamed up by Shakespeare.

DUNFERMLINE ATHLETIC FC
The club's badge looks back to Malcolm Canmore who based himself in the town. It features Canmore's Tower and was designed in 1957 by Dunfermline High School art teacher, Colin Dymock. All that is left of Malcolm Canmore's tower now are a few stones.

DID YOU KNOW? As a lad Shakespeare would probably have kicked a ball round the streets of Stratford-upon-Avon with his pals? He refers to football in his plays.

'Am I so round with you as you with me, That like a football you do spurn me thus?'
Comedy of Errors, Act 2 Scene 1

'I'll not be struck, my lord, nor tripped neither, you base football player.'
King Lear Act 1 Scene 4

WHY NOT? Write your own life story. Note the basic facts and then let your imagination take over. Imagine if a scout from a famous club discovers you. What happens next?

VISIT The magnificent Dunfermline Abbey built on the site of the church where Malcolm Canmore married the future St Margaret of Scotland.

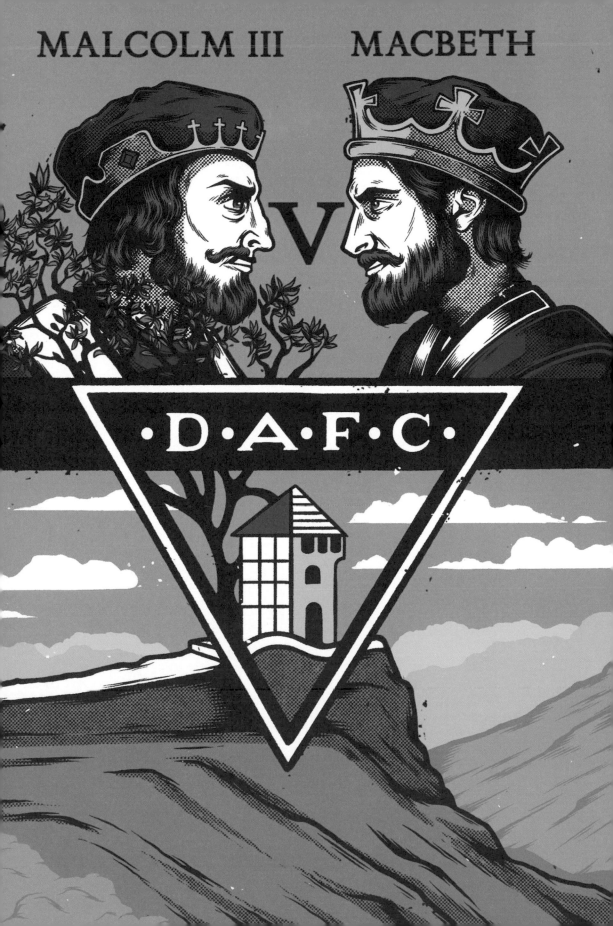

THE NORMANS

THE COURAGEOUS LEADERS MUTUALLY PREPARED FOR BATTLE, EACH ACCORDING TO HIS NATIONAL CUSTOM. THE ENGLISH PASSED THE NIGHT WITHOUT SLEEP IN DRINKING AND SINGING ... THE NORMANS PASSED THE WHOLE NIGHT IN CONFESSING THEIR SINS.

WILLIAM OF MALMESBURY
1140, OF THE EVE OF THE BATTLE OF HASTINGS

1086
COUNTING HEADS

Britain was far from settled after William the Conqueror took over. He was constantly on the lookout for rebels and even shook with fear of attack during his coronation.

He divided the land among his most loyal followers provided they defended the boundaries against rebel neighbours, creating ten Earls. Hugh d'Avranches, Earl of Chester was nicknamed 'Lupus', the wolf because he fought so fiercely against the Welsh princes and also Hugh 'the fat' because he loved feasting.

William was a great castle builder. The first thing he did on landing was to order Hastings Castle. Before then castles were virtually unknown in Britain. He used stone rather than wood for important buildings. By 1100 the landscape was dotted with around 1,000 castles from the massive Tower of London to wooden towers on top of mounds which could be put up quickly to house fighting men.

William wanted to find out about his new kingdom – who owned what, how many cows they had, who else lived there? He sent people throughout the land to investigate. Clerks wrote their findings into the *Domesday Book*, of 1086. Over 3,000 places were listed, most of which exist today.

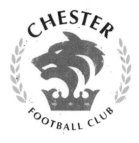

'LUPUS' - THE WOLF
Like many football clubs, Chester FC are a 'phoenix' club. Such clubs emerged from a previous club that had closed, often because of money troubles.

In 2010 a 'new' club was formed, dropping 'City' from its name, but playing in the same stadium and keeping many of its players.

A new badge was required. A hint of the flames of a phoenix was included as a nod as to how the 'new' club came into being.

DID YOU KNOW? The crown on the football badge refers to Chester being a Royalist stronghold, supporting King Charles I during the English Civil War of the 1640s.

WHY NOT? Find out if your street, village or town is featured in the Domesday Book.

VISIT A Norman castle near you – Norwich, Canterbury, York, Dover, to name but a few. The early ones were made of wood surrounded by a ditch. They were known as motte and baileys.

CHESTER CATHEDRAL
Spot the wolves lurking in the cloak and shield of Hugh d'Avranches from a stained glass window in Chester Cathedral.

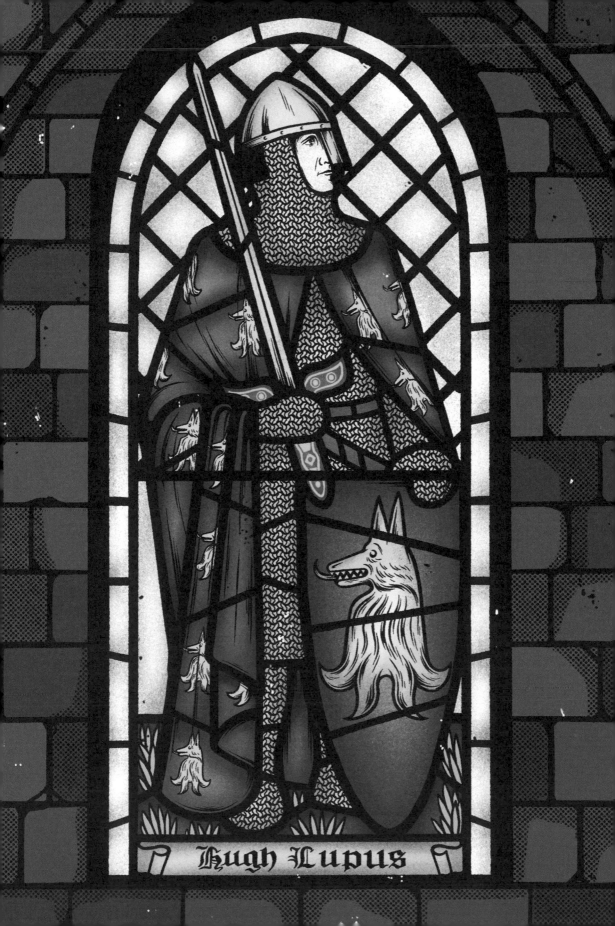

Hugh Lupus

LICENSED TO TRADE

As life became more settled, people lived together in towns and villages. Derby had a market and a mint to make its own coins centuries before King Henry II granted it a royal charter in 1154.

Farmers sold sheep and cattle and craftsmen worked in leather and wool in the market place.

William the Conqueror introduced the right to hold markets and fairs as a way of rewarding his best knights. With a vast empire in France to control as well as England, King Henry II continued the practice as did later kings. They issued royal charters, formal documents giving the townspeople certain rights.

The mascot of a regiment of soldiers, the nickname of a football club, a rhyme that the first US President, George Washington, sang to a friend's children, a statue of a giant beast all refer to a famous, ancient folk song, 'the Derby Ram'. Performers may have sung it round the houses for money. Here's how it goes:

'As I was going to Derby all on a market day,

I met the biggest ram, me boys

That ever was fed on hay.

Now all the men in Derby

Came a-begging for his eyes,

To pound up and down the Derby streets

For they were of a football's size.'

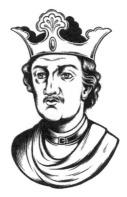

KING HENRY II
King Henry II had a French father and an English mother. He ruled over an Empire on both sides of the Channel. He is most famous for arranging the murder of his former best friend, Thomas, Archbishop of Canterbury over religious differences. Three of his five sons became King of England.

THE DERBY RAM
Derby County FC has always had a ram on its badge although the design has become simpler and the ram has changed direction over the years.

DID YOU KNOW? When the regiment's in town, a ram, Lance Corporal Derby, trots round the Derby County football ground.

WHY NOT? Sing a verse of the 'Derby Ram'.

VISIT Count the number of Derby Ram statues around town.

1167
STUDENTS WILL BE STUDENTS

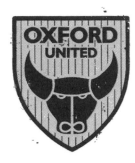

Oxford is the oldest University in the English speaking world. It was founded in 1167 after King Henry II banned students from studying at the University of Paris.

He encouraged learning because he needed good lawyers to handle his increasingly complex affairs.

Students studied subjects like grammar, arithmetic and how to argue, many classes starting at 5am. They attended lectures from their mid teens until their early 20s. Only the sons of the rich and powerful went to University. Nine out of ten people were peasants living off the land.

Relations between scholars and townspeople often led to riots and killings as students did not have to obey the law. Students stayed together in halls, many of which were run by monks, and later colleges for protection.

Living far from home, students had a reputation for drinking and wild behaviour. There was a bloody battle in 1209 after the town hanged three students, accusing them of killing a woman. Some scholars escaped to Cambridge to set up a second University.

Oxford and Cambridge Universities were rivals, long before the boat race. Cambridge claims to be the older because Henry III granted it a royal charter first, 17 years before he granted Oxford one.

GREEK INSPIRATION
The Oxford United badge was originally designed by famous author, Desmond Morris, who was a director of the club in the 1970s.

The bull was inspired by an early Greek carving like the one in the Ashmolean Museum, Oxford, the world's first public museum.

DID YOU KNOW? A previous badge set the bull's head against a background of water (above). It is a play on the name Ox-ford. The ford was a shallow place where people could cross the river Thames that flows through the city.

VISIT How many towns can you think of that end in 'Ford'? Your starter for ten – Telford, Romford, Stratford, Watford. Look on a map you will see they are near a river.

WHY NOT? Choose a name like Springford where each part of the word means something and make a picture of each part. This is called a rebus. They were popular at a time when most people couldn't read, a forerunner of today's emojis.

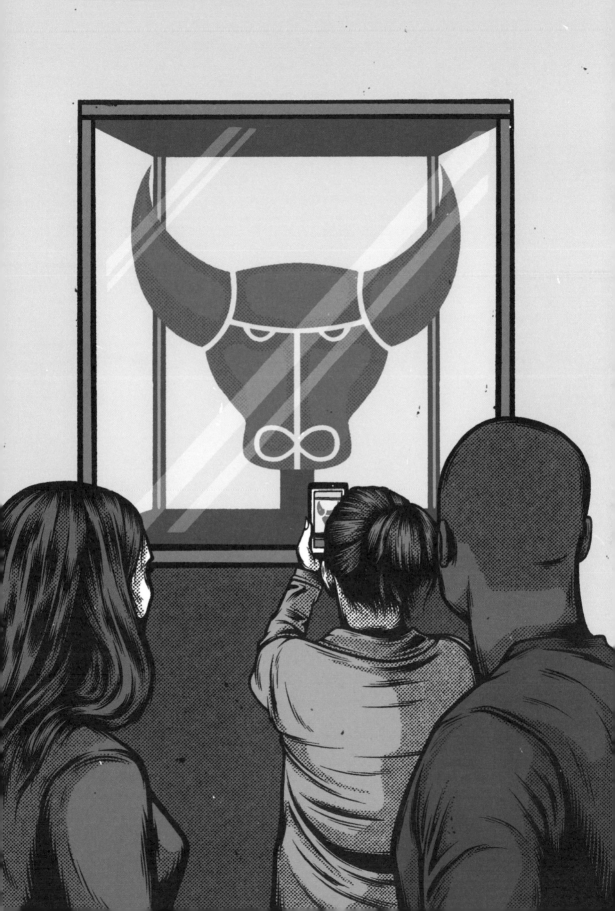

RICHARD - THREE LIONS ON MY SHIELD

The Crusades were wars fought by European Christians to recapture Jerusalem from the Muslims who also considered it a holy place.

Crusaders were promised forgiveness from their sins. Many died from disease, fighting or hunger.

Richard I joined the 3rd Crusade in 1189. He proved to be a great military leader like his enemy Saladin. He even hurled hives of angry bees into the port of Acre to break a siege. Richard was called the Lionheart as he was brave and was said to have put his arm down a lion's throat. He was within a day's march of Jerusalem when lack of resources forced him to turn back and make peace with Saladin.

Richard had to return to England in 1192 as his brother John was threatening to rebel. His journey home was a disaster. He was shipwrecked and then captured. The English had to pay a huge amount of money to buy his freedom.

Although crusades continued in the Eastern Mediterranean and in Spain, English kings had their own battles to fight over their French lands. Richard had only spent six months of his 10-year reign in England.

10 ROSES ON MY SHIRT
The badge on the English football team's shirts adds ten Tudor roses, as a reference to the union of the houses of Lancaster and York after the Wars of the Roses.

CRUSADERS FC
Crusaders FC is one of Northern Ireland's oldest football clubs, established around 1898. One of the founders wanted a name of international significance suggesting bravery so they opted for Crusaders.

DID YOU KNOW? How did three lions end up on football shirts.

The story begins with King Henry I whose symbol was a single golden lion. His second wife was Adeliza of Louvain whose father also favoured a lion. Henry added it to his arms. A later king, Henry II, married Eleanor of Aquitaine whose family crest again featured a lion. Their son Richard united the three lions into the national symbol it is today.

WHY NOT? See how many club badges you can find that feature lions.

VISIT An enormous statue of Richard the Lionheart on his horse is in Old Palace Yard outside the Palace of Westminster in London.

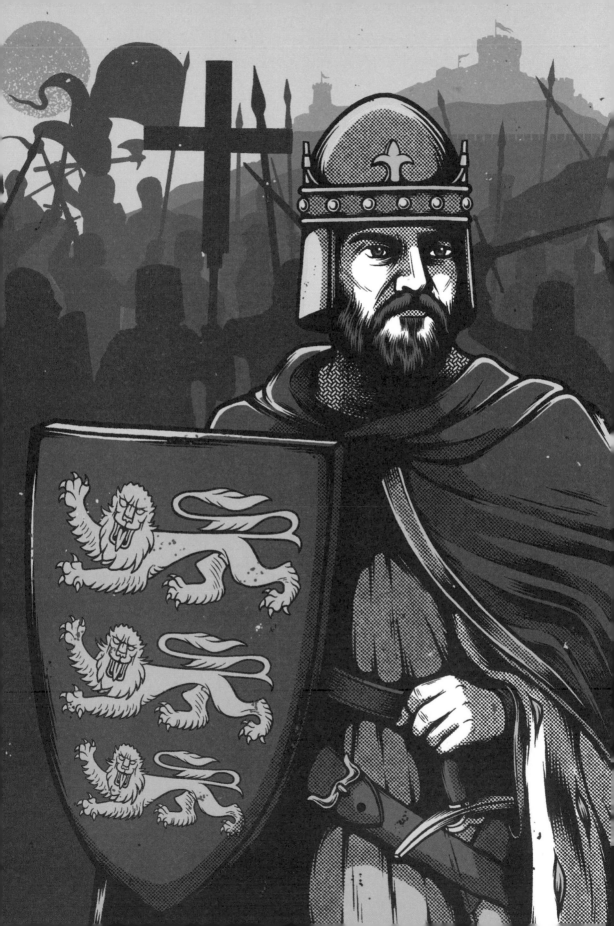

1215

THE GREAT CHARTER

The knight carries a sword in one hand and a parchment, made from animal skin, in the other.

This is no ordinary charter. It is Magna Carta running to 63 sections and 4,000 words.

'Bad' King John became king in 1199. Within five years he had lost most of England's land in France. He needed an army to try to win it back and taxed the people very highly to pay for it. He fell out with the Church and invasion and rebellion threatened.

The people were restless. Churchmen and barons met in St Albans Abbey in 1213 to discuss complaints against their unpopular king and how to restore order. Discussions led to Magna Carta, sealed by the king at Runnymede on the Thames in 1215. Magna Carta set out the basic rights and freedoms of common people, including trial by jury. It also limited the power of the king.

Three months later King John had wriggled out of the agreement but by the end of the year he was dead. Still relevant today, Magna Carta forms the basis of the rights of countries like the USA and Australia.

THE GREAT SEAL
King John approved Magna Carta with his great seal. Copies were sent round the kingdom, each carrying the seal. The images of John on the seal, sitting on his throne and riding a horse, are the best likenesses of the king that we have.

ST ALBANS CITY FOOTBALL CLUB
EST 1908

SPOT THE CHARTER
Magna Carta features on the coat of arms of the town of St Albans, which is also used as the badge of its football club.

Look carefully and at the top you can see a baron carrying the rolled-up charter. The other figures on the badge are an abbot of St Albans Abbey who once also ruled the town and a printer, as the town was an early centre of the trade.

DID YOU KNOW? John's older brother, Richard I, had emptied the royal money chest on his Crusade. John raised and collected taxes, ruled more efficiently and exerted his power over Scotland, Ireland and the Church. These actions made him unpopular with his barons.

WHY NOT? Create your own seal. Look at the great seal (above). Doesn't it look similar to some of today's football club badges?

VISIT Only four copies of Magna Carta survive, two in the British Library in London, one in Lincoln Cathedral and one in Salisbury Cathedral.

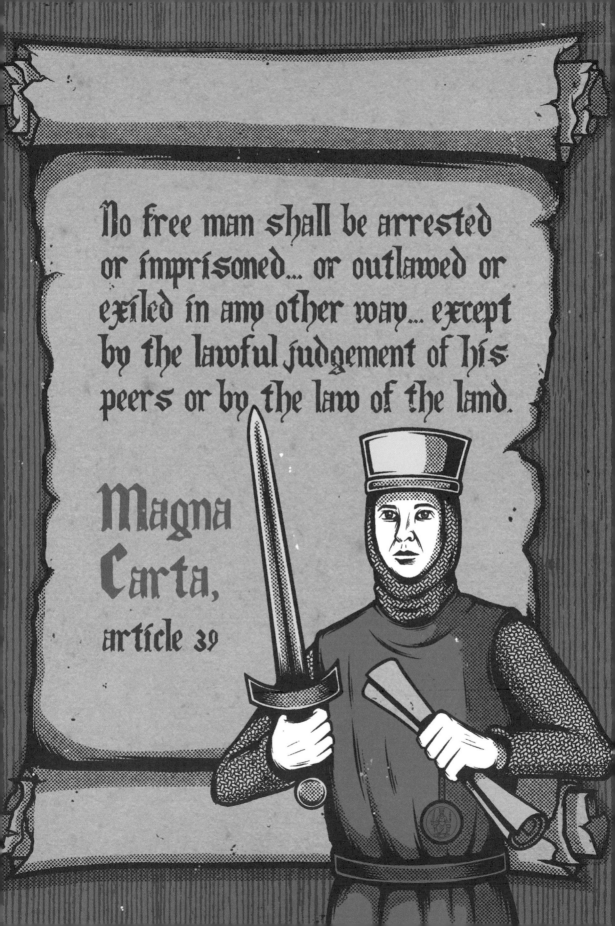

REACHING UP TO HEAVEN

The 13th century was the era of cathedral building.

A cathedral is the seat of a bishop who looks after an area called a diocese. The first cathedrals were often made of wood but later were replaced by stone.

They were regularly damaged by fire, war, lightning and earthquakes. Their architects were sometimes more ambitious than their knowledge about how to construct buildings in the new Gothic style.

The central tower of Lincoln Cathedral fell down during a service shortly after it was built. A spire was added when it was rebuilt making it the tallest building in the world (160 metres).

Thousands of craftsmen and labourers worked on building a cathedral. It could take centuries to raise the money for the next stage. They started work on the part of Lincoln cathedral called the Angel choir in 1256 and finished it in 1280. Some workmen liked a joke, carving wild beasts, devils or a monk with toothache and hiding them in places where they would not be seen.

Lincoln had an imp about whom there are many legends. One is that an angel turned him to stone when this child of the Devil would not stop making mischief in the cathedral.

The imp has become so famous that it is a symbol for the city and its football club.

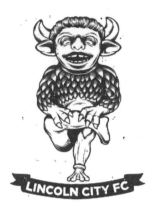

LINCOLN CITY FC
The imp has escaped from the Cathedral and found his way on to the badge of Lincoln City.

TALLEST BUILDING IN THE WORLD
Lincoln Cathedral, where the imp is hiding, was the tallest bulding in the world, overtaking the Great Pyramid of Giza. Before its spire blew down in 1549 it was higher than Blackpool Tower is today.

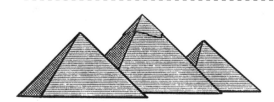

2550-2490BC
GREAT PYRAMID OF GIZA
146.5 metres (480.1 feet) tall when built.

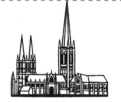

1311
LINCOLN CATHEDRAL
160 metres tall (525 feet).

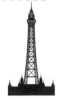

1894
BLACKPOOL TOWER
158 metres tall (518 feet).

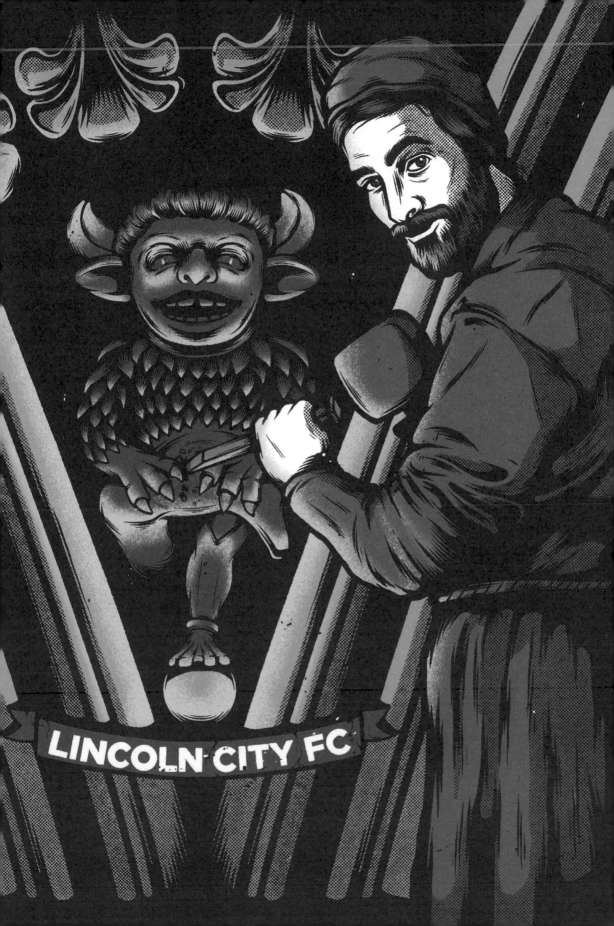

1263

O FLOWER OF SCOTLAND

The Battle of Largs of 1263 was the last battle against the Vikings. It gave rise to Scotland's national flower, the thistle.

By now mainland Britain was free of Vikings but the Scottish islands were still owned by Norway.

After years of the two sides battling it out for control, Alexander III, the King of Scots, having made raids deep inside Norway, enough was enough. Haakon IV of Norway had gathered a mighty fleet of 120 ships and up to 20,000 men by the time he reached the mouth of the river Clyde. Alexander knew that he could not defeat the fleet so he delayed until the autumn storms came and scattered the ships. He attacked the Norsemen who managed to land.

It is said that some Norwegians planned to creep up on the Scots and capture them unawares at night. They took off their footwear to make less noise but one soldier stood on a thistle and screamed. His cry of pain gave the game away.

Although it was not clear who had won the battle the Norwegians lost interest and handed over the Hebrides and the Isle of Man although they kept the Northern Isles of Orkney and Shetland.

DID YOU KNOW? The nickname for Partick Thistle FC is the Jags. Scots know that a thistle is jaggy meaning prickly.

WHY NOT? Find out what the national flower of your country is and why. How many football badges does it appear on?

VISIT The memorial to the battle in the Clyde resort of Largs is nicknamed the 'pencil'. Have a look and you will see why.

WATCH OUT FOR THISTLES

Partick Thistle are one the most famous Scottish clubs to have a thistle in its name and on its badge, others include:

Ardeer Thistle FC

Armadale Thistle FC

Bathgate Thistle FC

Bridge of Don Thistle FC

Buckie Thistle FC

Bunillidh Thistle FC

Burghead Thistle FC

Dalkeith Thistle FC

Dalry Thistle FC

East Kilbride Thistle FC

Forres Thistle FC

Inverness Caledonian Thistle FC

Kilbride Thistle AFC

Kirriemuir Thistle FC

Largs Thistle FC

Larkhall Thistle FC

Lochar Thistle FC

Lothian Thistle Hutchison Vale FC

Lugar Boswell Thistle FC

North End Thistle FC

Scone Thistle FC

Springburn Thistle AFC

Strathspey Thistle FC

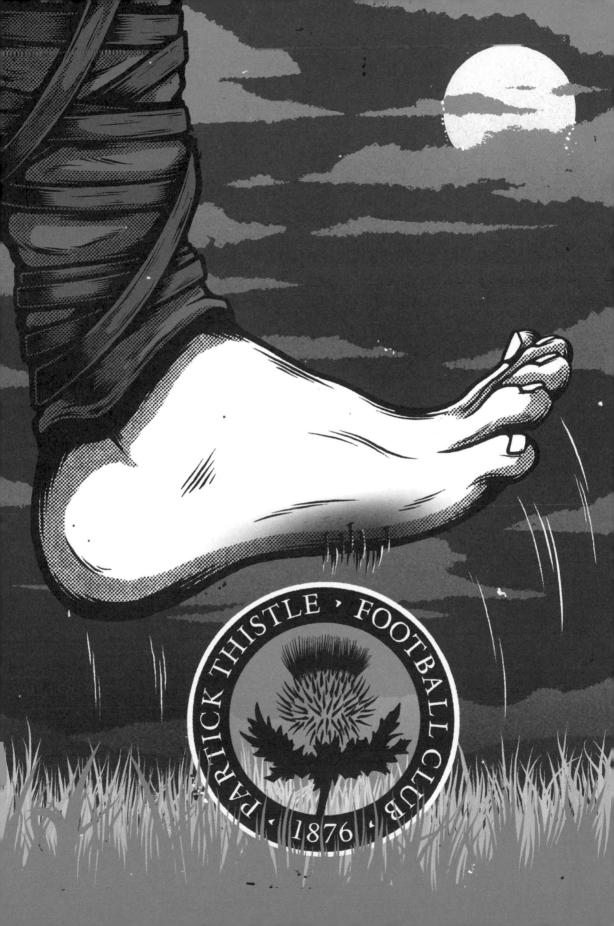

1297
SCOTS WHA HAE...

... Wi Wallace bled. This is the first line of the poem by Scotland's national poet, Robert Burns, celebrating the country's victory in the Wars of Independence.

William Wallace was a hero of the early years of conflict. He was said to have watched Edward I's army gathering, from the crag outside Stirling on which the Wallace Monument now stands.

Edward I of England was a powerful and ambitious king. He had already built a ring of castles to keep the Welsh in check. Scotland was next on his list.

Scotland's king, Alexander III, fell off his horse and his heir, the Maid of Norway, died on the crossing to Scotland. The Scottish nobles invited Edward to choose the next king. He picked John Balliol but he was a poor choice and Edward forced him to give up the crown.

In 1297 led by knight William Wallace, the Scots were in rebellious mood. Wallace defeated Edward's army at Stirling Bridge, trapping many soldiers on the narrow bridge itself.

The following year he lost the Battle of Falkirk and handed over power to Robert the Bruce. He went on the run before being captured and hung, drawn and quartered in London.

STIRLING ALBION FC
The Stirling Albion badge features the National Wallace Monument, built on a rocky crag in 1869 and funded by the Scottish people to honour William Wallace.

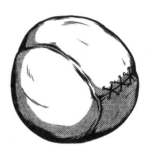

THE OLDEST FOOTBALL
The Smith Museum in Stirling displays the world's oldest football. Someone must have kicked the ball high during a game in Stirling Castle in the 1540s as it became stuck in the rafters of the Great Hall. The leather ball was inflated with a pig's bladder. Mary Queen of Scots may have delivered the kick as football was a favourite game of hers.

DID YOU KNOW? The name for Scotland in many Celtic languages is Alba.

WHY NOT? Watch the film. Hollywood made William Wallace famous as *Braveheart* in 1995, and won five Academy Awards including Best Picture. The plot is more fiction than fact.

VISIT The Wallace Monument in Stirling. You can visit three floors of exhibitions or climb 246 steps for a stunning view from the top.

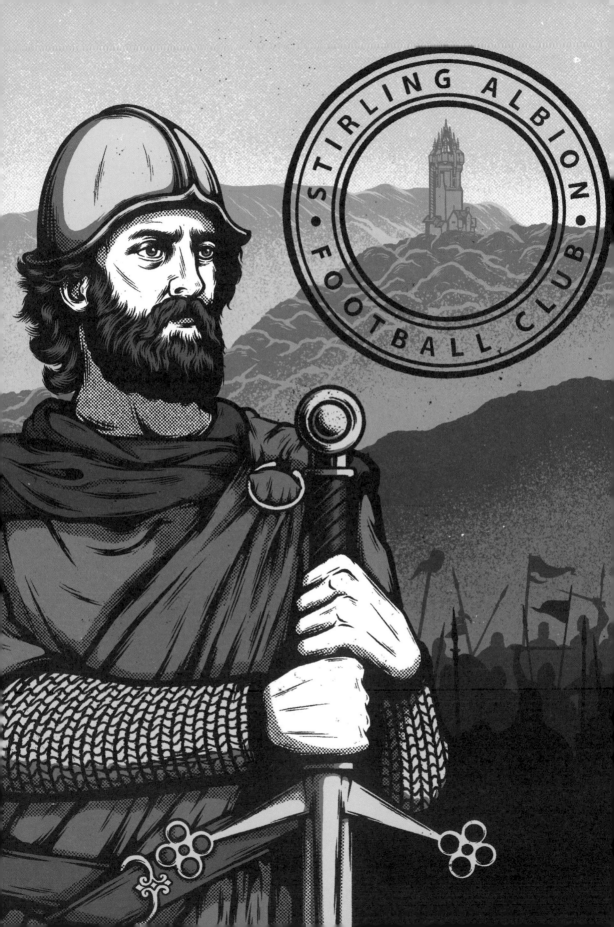

1349
THE BLACK DEATH

This plague killed nearly half the population of Britain and up to 200 million people worldwide.

It was carried by fleas that lived on rats and bit humans and spread by lice and fleas. Sufferers had a high temperature and broke out in black, smelly boils. Death followed very quickly. Gravediggers could not keep up and so bodies were tossed into huge pits to be buried.

The aftermath was severe. Some people believed that God was punishing them. Food was scarce as there were not enough workers to gather in the harvest. Skills in most trades were in short supply and people left for better jobs or to earn more pay. The king tried without success to keep workers in their old jobs at their old pay.

The Black Death of 1349 had one unexpected result. Chesterfield in Derbyshire is the only town in Britain whose church has a twisted spire.

Although the Devil plays a part in many stories of how this happened, one reason is that the skilled craftsmen had died and less experienced workmen used timber which had not been left out to dry. The weight of the lead covering it twisted the 69.5 m (228 feet) high spire. Even church architecture changed to a simpler style with straight lines, known as perpendicular, because it was easier to build.

TWISTED OR CROOKED?
The spire of the church of St Mary and All Saints is featured on the logo of the local council, as well as the badge of Chesterfield FC. The club's nickname is The Spireites, and a club fanzine was named *Crooked Spireite*.

DID YOU KNOW? Several local legends feature the Devil wrapping his tail round the spire. One tells of him doing a gigantic sneeze causing his tail to twist it out of shape.

WHY NOT? Look for a perpendicular building, sometimes the main church in your town centre. The Victorians revived it as a style for banks, churches and town halls. You can tell the style by straight, up and down lines and wide windows.

VISIT The church of St Mary and All Saints is right in the centre of the town.

1381
REVOLTING!

The Peasants' Revolt was the first great popular uprising in English history.

The trigger was the poll tax, needed to pay for Richard II's wars in France. Although everyone had to pay, many refused. They were also unhappy at attempts to keep down their pay after the Black Death.

The rebellion only lasted a month. Men from Essex and Kent under their leader Wat Tyler marched on London, armed with bows, sticks and farm implements like scythes. They forced the king to negotiate although he did not keep his promises. The angry Lord Mayor of London killed Tyler in front of the king. His head was put on a pole as an example.

The natives were restless throughout the land. Local riots continued and the great nobles too were unhappy. The greatest warrior of all was Harry Percy, son of the 1st Earl of Northumberland. He was called Hotspur because he urged his horses to greater speeds and was always ready to attack. He fought the Scots who called him Hatspore, the Welsh, the Irish, the French and eventually his king over money. He died in battle against him in 1403.

EAST THURROCK UNITED FC

East Thurrock United FC chose to make the link with the Peasants' Revolt by showing a local wielding a bloody scythe.

HARRY, HE'S ONE OF OUR OWN

The name of Henry Percy is recalled by Tottenham Hotspur FC because their first ground in Tottenham Marshes was near land owned by one of his descendants.

Henry Percy 'Hotspur' is featured in Shakespeare's play Henry IV, Part 1.

DID YOU KNOW? East Thurrock United FC features the Peasants' Revolt on its badge because one of the leaders came from the nearby Essex village of Fobbing. Did residents join the second Poll Tax riots of 1990? Officially titled the Community Charge it was introduced by the government as a new way of raising money to pay for local government.

WHY NOT? Choose a football team whose name suggests a strong performance on the pitch. Would you choose Hotspur, Trojan, Crusader or Centurion? For a time East Thurrock United played in the London Spartan League, named after one of ancient Greece's most warlike armies.

VISIT The Tower of London where the king hid from the rebels who attacked it. The next day Richard II rode out to meet the rebel leaders outside London. He was only 14 years old.

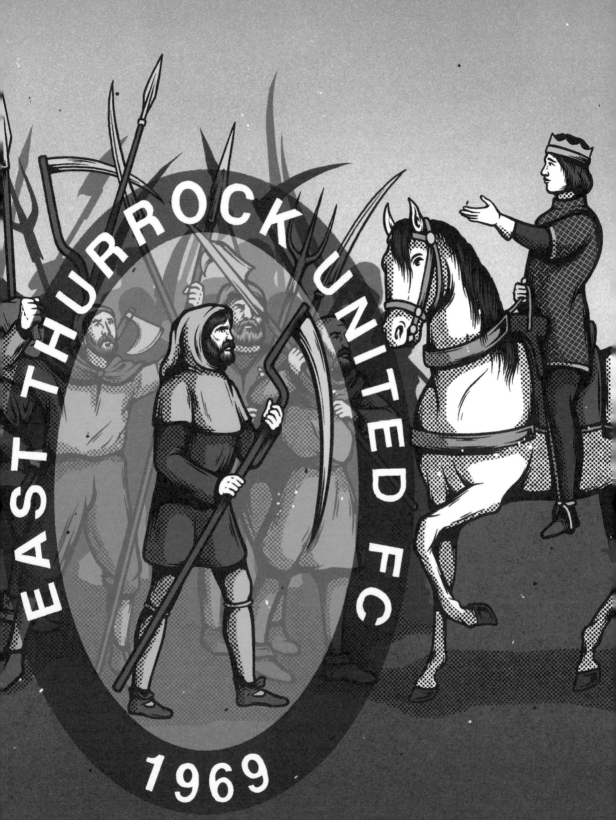

THE TUDORS AND STUARTS

NOR TRIPPED NEITHER, YOU BASE FOOTBALL PLAYER.

WILLIAM SHAKESPEARE
KING LEAR (1605-06)

1485
FAMILIES AT WAR

The Battle of Bosworth Field, in 1485, ended the Wars of the Roses, a fight between two branches of the House of Plantagenet for control of the English throne.

They both claimed descent from Edward III. The future Henry VII and the Lancastrians beat the Yorkists after nearly 30 years of fighting. Richard III, the Yorkist king died in the battle.

Yorkists may have sometimes used a white rose to show whom they supported. The Lancastrian red rose was adopted only after the victory of Henry Tudor at the Battle of Bosworth. Both families had their personal battle badges – the Lancastrians, the red dragon and the Yorkists, the white boar. Henry combined the red rose and the white to form the Tudor rose to suggest that the two houses were united. It became England's national flower.

Henry VII brought the families together by marrying Elizabeth of York, the daughter and heir of Edward IV. He made sure that everyone recognised the Tudor rose, on buildings, paintings and in verse.

Centuries later the red rose of the House of Lancaster and white rose of the House of York have been taken to symbolise the two counties, which is very different from the private family emblems they began life as.

THE TUDOR ROSE
The Tudor rose appears on the badge of Sutton Coldfield Town FC. The town uses the emblem frequently, to celebrate King Henry VII granting it special privileges.

NORTHAMPTON TOWN FC
The town of Northampton used the rose on its badge to suggest its loyalties to both the Lancastrians and the Yorkists.

DID YOU KNOW? The badge of Barnet FC has both a white and red rose signifying the Battle of Barnet (1471). This was one of the key events in the struggle with Yorkist Edward IV regaining the crown from Lancastrian Henry VI.

WHY NOT? Count the number of clubs with badges featuring a white rose or a red rose. Which side wins?

VISIT Westminster Abbey to see the grand tomb of Henry VII, or King Richard III Heritage Centre in Leicester where the king's body was found buried in a car park in 2012.

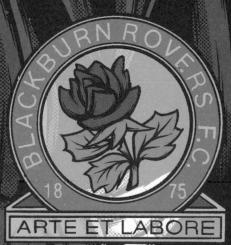

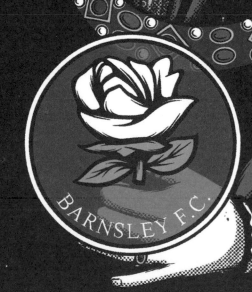

Hedgeley
Moor 1464

Hexham
1464

Towton
1461

Ferrybridge
1461

Wakefield
1460

Blore Heath Losecote
1459 Field 1470

Ludford
Bridge 1459

Mortimer's Northampton 1460
Cross 1461
 St.Albans 1455
Tewkesbury St.Albans 1461
1471 Edgecote Barnet 1471
 Moor 1469

BLACKBURN ROVERS F.C.

18 75

ARTE ET LABORE

BARNSLEY F.C.

Henry VII Richard III

1509

KING HENRY 8
WIVES 6

Henry VIII loved to have his portrait painted. That's why he is one of Britain's most recognisable kings.

He burst on to the scene aged only 18. His father Henry VII was unpopular for high taxes, strict laws and his belief that Yorkists were plotting to overthrow him. Arthur, Henry's older brother, died before he could inherit the crown. Becoming king in 1509, Henry was light relief. He loved feasting, hunting, women and sports. He ordered the world's first known pair of football boots although he later tried to ban the game as it led to riots.

Above all Henry wanted a male child. When Catherine of Aragon, his first wife, grew too old, he divorced her. To do this he had to break with the Pope and declare himself to be head of the Church of England. He saw a way of growing even richer by stripping the monasteries of their wealth: they owned a quarter of the land. Five wives later, Henry died leaving one son (Edward VI) who died before he was old enough to rule.

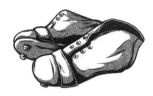

HENRY'S BOOTS
Henry had what are thought to be the first pair of boots made specifically to play football. Costing four shillings, nearly £100 in today's money, they were made by his personal shoemaker, Cornelius Johnson, in 1525.

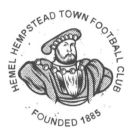

HEMEL HEMPSTEAD TOWN FC
In 1539 Henry granted the town of Hemel Hempstead in Hertfordshire a weekly market. The club have marked this by featuring Henry, in his famous pose. Was he wearing his football boots, at the time?

DID YOU KNOW? The badge of Hemel Hempstead Town FC is based on the famous painting of Henry by Hans Holbein the Younger in 1536. Like many top footballers today Henry was very aware of the importance of his image. He encouraged other artists to copy Holbein's painting and sent them round the country. The original was lost in a fire but several copies survive.

WHY NOT? Remember what happened to Henry's six wives – divorced, beheaded, died, divorced, beheaded, survived.

VISIT You can see copies in the National Portrait Gallery, London, Hampton Court Palace, the Walker Art Gallery in Liverpool and several country houses.

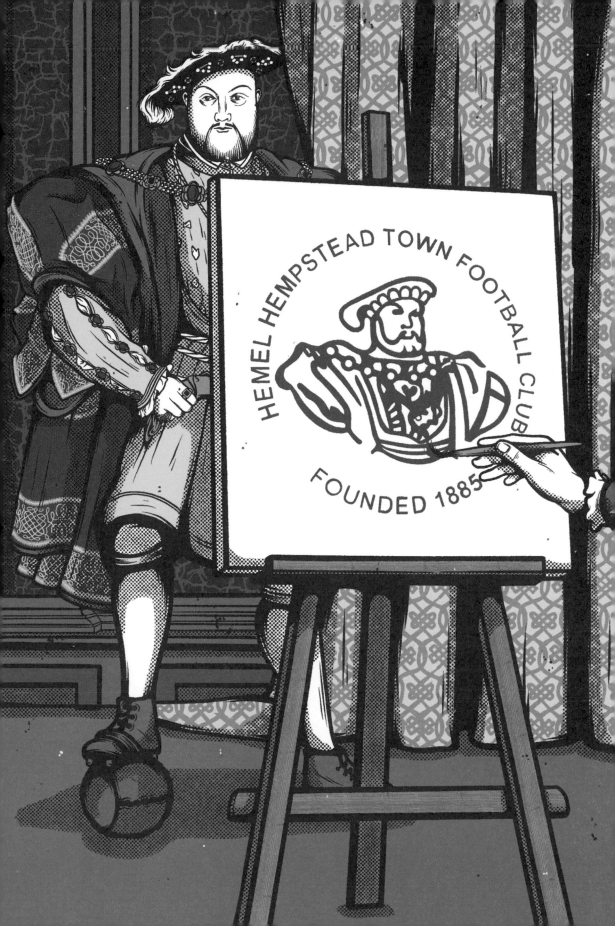

1566
WELCOMING THE STRANGERS

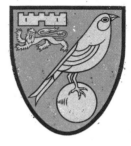

Religion was a hot topic. Europe was in turmoil. Countries like England had adopted the Protestant faith although some groups like the Puritans felt that reforming the Church had not gone far enough. Catholic countries became even more Catholic.

Catholic Spain had invaded the Netherlands and Belgium and exiled thousands of Protestants for their faith. They became refugees.

At the time Norwich was second in size only to London. It had grown wealthy from the wool and cloth trade but needed new skills especially in weaving. The authorities invited exiled families to settle in Norwich in 1566. They were known as the Strangers.

At first they lived in tight-knit communities, speaking a different language and having a separate culture and faith. By the end of the century they made up a third of Norwich's population and had started to marry local people.

Many of the Strangers were weavers and bred canaries for company. They brought their birds with them. The birds became popular with the locals, leading to a new breed known as the Norwich canary. In the 19th century the breed was so popular that it was exported to the USA, a keeper travelling across the Atlantic with the birds.

SING WHEN YOU'RE WINNING
Before football brands became big business, clubs often held a competition when they wanted a new badge. The design of the current Norwich City badge was the winning entry in a competition in 1971. Andrew Anderson recalled ...

As a prize I was given £10 and two directors' box tickets for a game played in the rain that City lost.

DID YOU KNOW? The winning design featured not only the famous canary but also Norwich Castle, ordered to be built by William the Conqueror.

WHY NOT? When in Norwich look out for the Castle (right) - high on a hill overlooking the football ground, Carrow Road.

VISIT Strangers Hall museum in Norwich. Documents show that some Strangers may have stayed there.

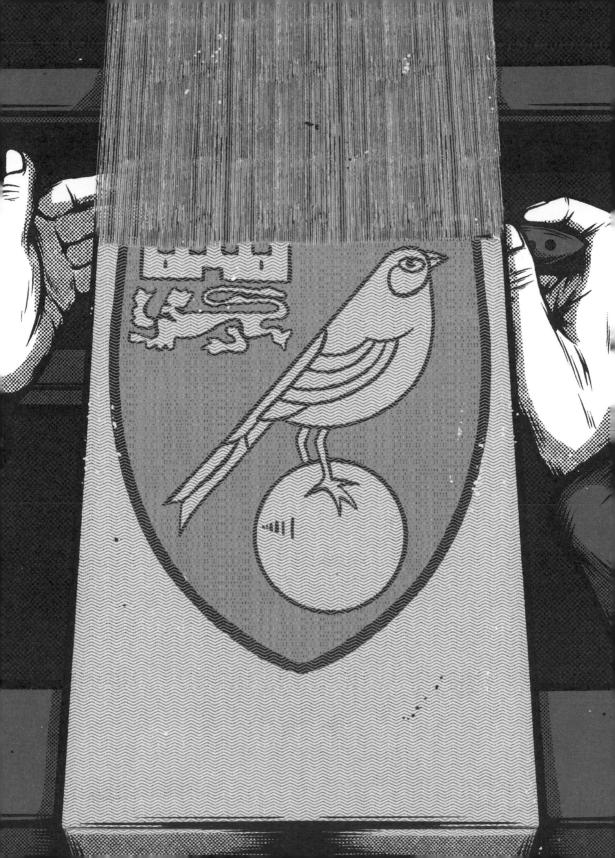

THE HEART OF A KING OF ENGLAND

After five years of Catholic rule by her half-sister, Mary, Anne Boleyn's daughter Elizabeth became Queen. She ruled for nearly 40 years. The Protestant faith was here to stay.

Elizabeth I was a sensible ruler surrounding herself with a court of over 1,000. She adopted the motto 'I see but I say nothing.' She was popular and became a celebrity although she never married. She loved fashion, display, dancing and theatre. Vain about her looks, in old age she wore a red wig and an inch of white make-up.

This was the age of exploration to find trade routes to the Far East for silks and spices and to rob Spanish treasure ships laden with gold and silver from South America.

Elizabeth encouraged adventurers like Sir Francis Drake, the first captain to sail round the world. She made him a knight on his return in 1580. He served her well when eight years later he helped to destroy an enormous Spanish fleet, the Armada, gathered in the Channel to invade England.

On her death James VI of Scotland inherited the crown despite her ordering his mother, the Catholic Mary Queen of Scots to be beheaded. He united England and Scotland.

In her portrait painted to celebrate the Armada victory, Elizabeth rested her hand on a globe to show her power and plans to build an overseas empire. Birmingham City FC included a globe on their badge, to stress their international ambitions.

BRAVE NEW WORLD
The Birmingham City 'Globe' badge was designed in 1972 by Michael Wood - a gas engineer from Walsall - whose design was chosen because it reflected the club's ambitions to play in European competitions.

DID YOU KNOW? Like footballers today Elizabeth I signed many autographs. The R stands for Regina, Latin for 'Queen'.

WHY NOT? Create your own autograph or those of your team's top players.

VISIT Check out the real thing. Slightly different versions of Elizabeth I's Armada portrait hang at Woburn Abbey, in London's National Portrait Gallery and at the Queen's House, Greenwich.

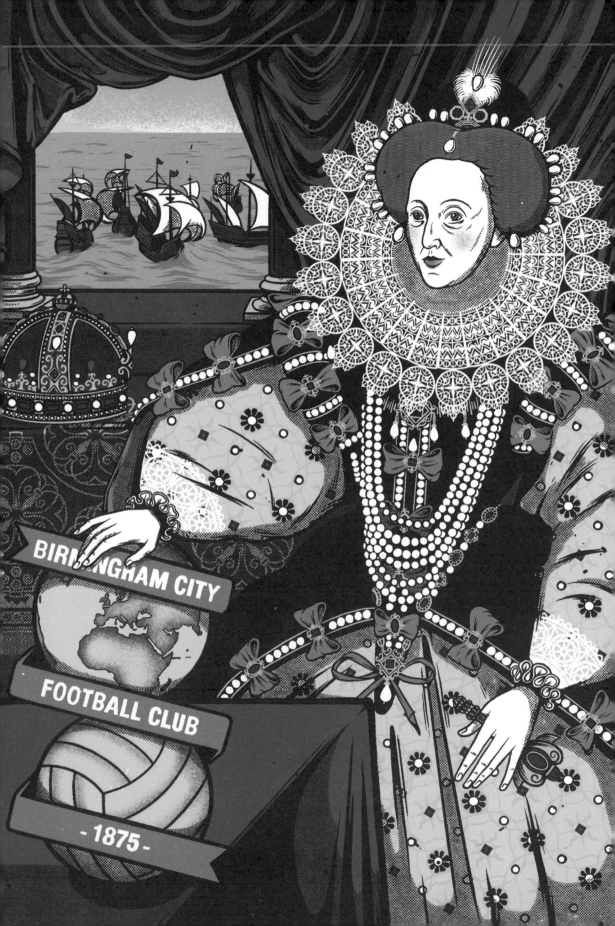

1620
A NEW LIFE IN THE NEW WORLD

This was the year that 102 people sailed on the *Mayflower* to America.

The Puritans wanted freedom to worship in their own simple way and escape punishment for their beliefs. Others were looking for the chance to trade.

Two ships set out from Plymouth. The *Speedwell* let in water and had to return to port. Passengers on the *Mayflower* included two dogs and a baby born at sea. The ship reached America 66 days later.

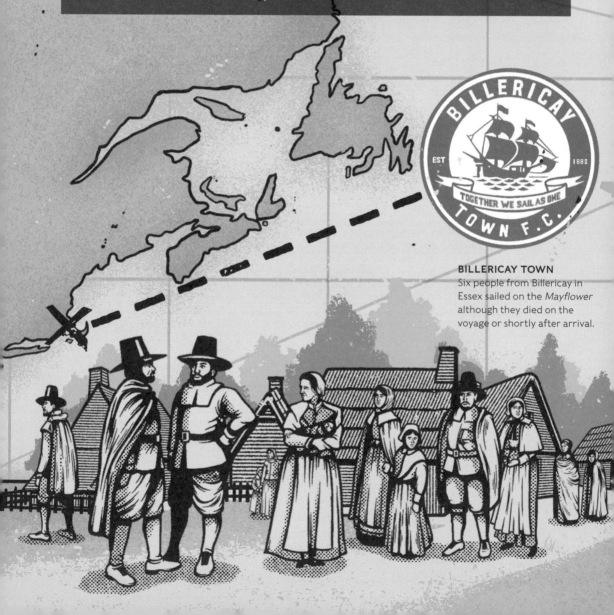

BILLERICAY TOWN
Six people from Billericay in Essex sailed on the *Mayflower* although they died on the voyage or shortly after arrival.

PLYMOUTH ARGYLE
Plymouth Argyle honours the port in Devon from which the *Mayflower* sailed. The club's mascot, Pilgrim Pete dresses just like the characters you see below.

BOSTON UNITED
Boston United are called The Pilgrims as many of the original pilgrims came from Lincolnshire.

The first Thanksgiving

Half the settlers died in the first winter from hunger and disease before the Wampanoag native people taught them how to fish and grow crops. They shared a harvest meal together in 1621, the origin of America's celebration of Thanksgiving. Soon others joined them and New England prospered.

More Americans now celebrate Thanksgiving than Christmas although traditions like eating turkey were added later. Thirty million Americans claim to be descended from the Pilgrim Fathers.

DID YOU KNOW? Peregrine White was born while the *Mayflower* was anchored in Cape Cod in late November 1620. He became known as the 'first born child of New England' and was a prominent farmer and military captain.

WHY NOT? Retrace the Pilgrims' route from Lincolnshire to Massachusetts in an atlas.

VISIT The Mayflower Steps in Plymouth close to the *Mayflower*'s departure point.

1642
KICK-OFF.
KING V PARLIAMENT

For nine years family fought family as England battled it out between King and Parliament as to who had control.

Generally the church and the gentry supported the King and the merchants Parliament. There were three civil wars and wars in Scotland and Ireland.

One of the first battles was in Haywards Heath in Sussex whose football club remembered it by featuring both sides on its badge. A cavalier stands for the King's men and a Roundhead for Parliament, many of whose members were Puritans. Roundheads wore round helmets and cut their hair short while Cavaliers dressed fashionably with big hats like their king.

Why war? Parliament was worried that Charles planned to bring back the Catholic faith and take over control believing that a king's right to rule came directly from God. Charles needed Parliament to raise taxes.

Final victory for Parliament was helped by Oliver Cromwell, a Puritan MP who raised an army of tough professional soldiers. Both sides fought fiercely with horsemen, gunners using weapons called muskets and pikemen carrying long poles.

Charles was captured, tried by Parliament and put to death and his son was forced to flee. England was without a king. Oliver Cromwell ruled during the 1650s.

THE BATTLE OF MUSTER GREEN

The Battle of Haywards Heath, also known as the Battle of Muster Green, was a minor skirmish between Cavaliers and Roundheads at the start of the first English Civil War.

The more disciplined army of the Roundheads were victorious leaving 200 Royalists dead, wounded or captured.

DID YOU KNOW? The English Civil Wars killed a higher proportion of the population than any other. In the seven years between 1642 and 1649, 1 in 10 of the adult male population died, more than three times the proportion that died in the First World War.

WHY NOT? Find a hole in a tree to hide in when escaping like the future Charles II's Royal Oak.

VISIT Take a stroll in Muster Green, now an open space in the centre of Haywards Heath. Imagine the noise of battle in 1642.

1660
THE MERRY MONARCH

After the Civil War and the rule of Oliver Cromwell, who closed theatres, expected people to dress in black and even banned Christmas, the people were ready for some fun.

They got it in King Charles II whom the army invited to return from exile in France in 1660.

Charles II loved spending money on wine, women and song. He followed the latest fashions and encouraged sport from horse racing to yachting. He invested in paintings, music, science and drama. Not all, however, was well in Charles' reign. In 1665 an outbreak of plague killed 68,000 Londoners alone. The next year much of the city burned down in the Great Fire of London. Fires burned for four days and destroyed the homes of seven out of eight of the inhabitants.

The fire provided the opportunity to rebuild the city, this time in stone. Many buildings including St Paul's Cathedral were designed by one of Britain's greatest architects, Sir Christopher Wren. In 1681 Charles decided to build a home for retired or injured soldiers, the Royal Hospital, Chelsea. Wren designed the building which housed 472 men. It is still home to the Chelsea Pensioners today.

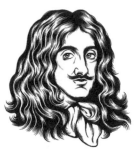

KING CHARLES II
Charles II loved having his portrait painted in different moods from merry to glum. His large nose was always to the fore.

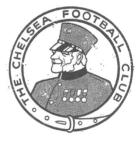

CHELSEA PENSIONERS
Chelsea Football Club has been linked to the Chelsea Pensioners for many years. Until the 1950s the club badge featured a Chelsea pensioner.

The Pensioners are regulars at Chelsea games. When the players were presented with the trophy for winning the Premier League in 2005, Chelsea Pensioners formed a guard of honour.

DID YOU KNOW? In 2019 Chelsea Pensioner Colin Thackery became the oldest winner of *Britain's Got Talent*, aged 89.

WHY NOT? Find out about the buildings that were designed by Sir Christopher Wren.

VISIT The Royal Hospital, Chelsea. Itself a living museum, it also has an exhibition area displaying some of its more unusual items. What were they used for? What role do they play today?

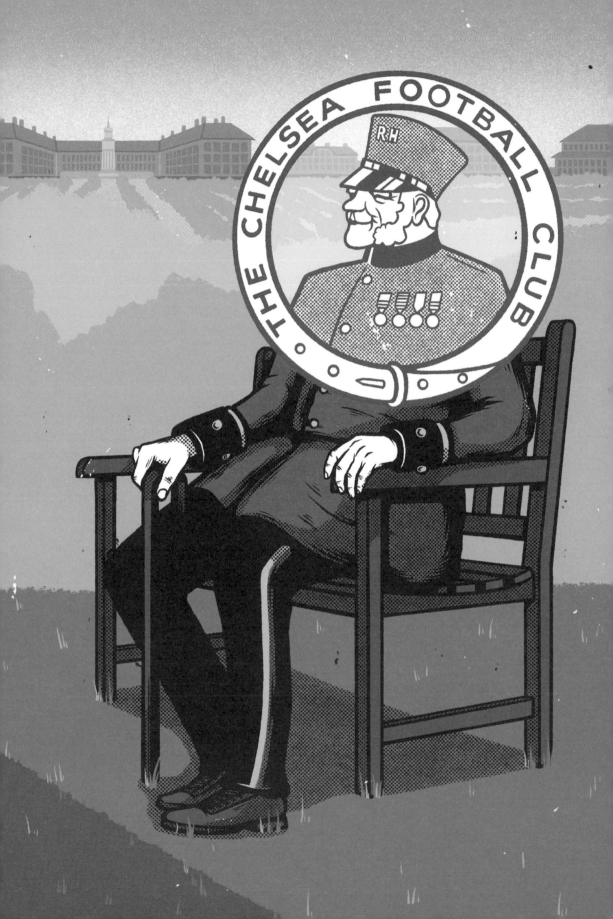

SCOTTISH OR ENGLISH?

The Border town of Berwick-on-Tweed is 2.5 miles (4 km) south of the Scottish border. It changed hands 14 times during the medieval wars between the two countries.

Although in England since 1482, its football team plays in the Scottish league. This is why it has two different lion rampants on its badge, the national symbol for each country.

Worried about Scottish support for the Catholic Stuarts, William III first suggested merging the Scottish and English Parliaments in 1689 but there was little interest on either side. In the 1690s Scotland suffered a number of blows including poor harvests and the failure to set up a South American colony in which many Scots had invested. Scottish merchants also wanted access to trade with the English colonies.

Negotiations dragged on for years before the Acts of Union of 1707 merged the Parliaments. Scotland kept its own laws and religion but shared taxes, coins, trade and a flag with England.

Seven years later Britain had a new royal family. The last Stuart, Queen Anne, was childless. Her nearest relative, the great grandson of James I, was George. He was old, German and not interested in British affairs but he was Protestant.

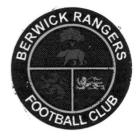

BERWICK RANGERS FC
The crest of Berwick Rangers FC was originally just the bear chained to the tree from the local council coat of arms. The badge was changed in the early 1990s by adding the Scottish and English lions.

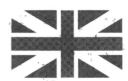

UNION FLAG
It came into use as a national flag following the Treaty of Union and Acts of Union 1707. Can you spot the difference between it and the Union Flag today?

DID YOU KNOW? For much of its course the border with Scotland runs along the middle of the river Tweed. Between the villages of Wark in England and Cornhill in Scotland the border crosses the Tweed to the south and encloses a riverside meadow known as the Ba Green. In past centuries the men of the two villages would play a wild and primitive game of football and the winners would claim the Ba Green for their country.

WHY NOT? Design your own flag for the Kingdom of Great Britain.

VISIT Berwick-upon-Tweed is a town with a past. Explore the Old Town in the Berwick Museum and Art Gallery, walk the Elizabethan walls or visit the 18th century Barracks where soldiers must have kicked a ball to pass the time.

THE GEORGIANS

IN 1969 I GAVE UP WOMEN AND ALCOHOL – IT WAS THE WORST 20 MINUTES OF MY LIFE.

GEORGE BEST
(BUT PRINNY, THE FUTURE GEORGE IV
COULD EQUALLY WELL HAVE SAID IT)

1718
BLACKBEARD

This was the year when the Royal Navy finally captured Blackbeard, Britain's most famous pirate.

Blackbeard was born in Bristol, at the time a booming port. Captains and merchants were rich on the new Atlantic trade with colonies like America and the West Indies. Acting as private warships, they also captured and robbed foreign ships for their treasure. They were called privateers.

Blackbeard was a sailor's son who ran away to sea. He based himself in the Bahamas, turning to piracy after years as a seaman and privateer. He may have seen himself as a Robin Hood, robbing rich merchants to give their money to ordinary people.

He owned three ships with a crew of 400. He was a larger than life character. Tall with bulging eyes, he married 14 times and had 40 children. He wore a long black coat with six loaded pistols tucked into his belt. He put gunpowder fuses in his beard to make it smoke and crackle and laced his rum with gunpowder.

Pirates also operated on a smaller scale. They smuggled goods like brandy and fine cloth from Europe into secret coves far way from the eyes of the customs men whose job it was to collect taxes on such luxuries.

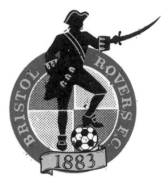

THE PIRATES
It is believed that Bristol Rovers FC gave itself the nickname the Pirates as early as the 1880s although he did not appear on the badge until 1997. He looks like Blackbeard, but we can't be sure!

DID YOU KNOW? In 2011 Blackbeard appeared in the most expensive film ever made, *Pirates of the Caribbean: On Stranger Tides* at a cost of $378.5 million.

WHY NOT? Draw a picture of what you think Blackbeard looked like.

VISIT You cannot escape Blackbeard in Bristol – walking tours, pub names, and there is even talk of a statue.

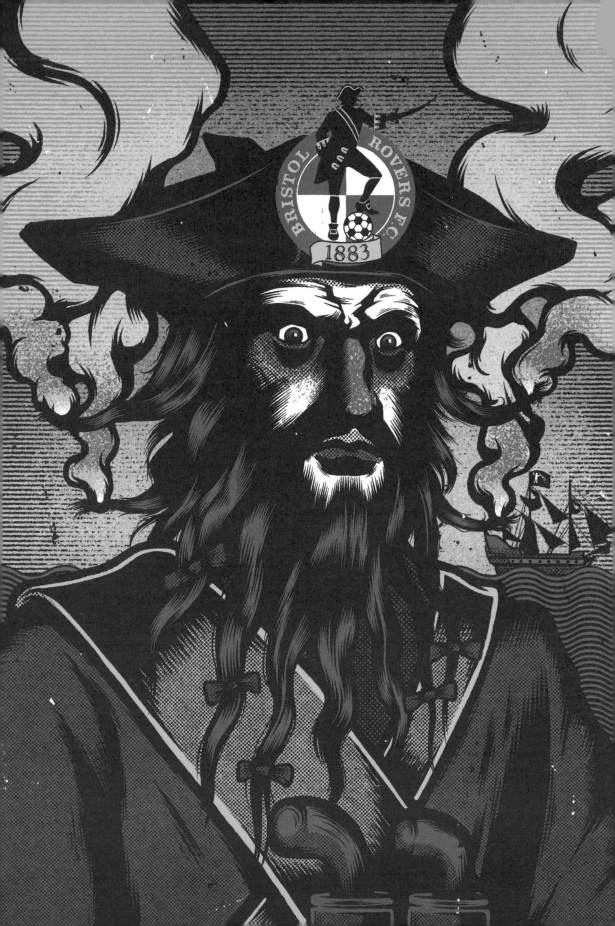

1746

THE LAST BATTLE ON BRITISH SOIL

The Catholic Stuarts did not give up the British throne easily. The exiled James II's son briefly invaded Scotland in 1715 before returning to France defeated.

His son, Charles Edward Stuart, was romantic and young. He landed on the west coast of Scotland with only nine men but won enough support from the Highland chiefs to defeat Government forces and march as far south as Derby, only 100 miles from London.

Then he turned back on the advice of his fellow leaders. His army was cold and tired and few English Catholics had joined it. Had he known, the authorities in London were panicking and preparing to flee.

In January 1746, on his way north he unexpectedly defeated the Government's troops at Falkirk between Glasgow and Edinburgh. The weather was miserable, daylight was short as it was midwinter and the Government troops scattered at the famous Highland charge.

This was a fast attack at close range with the soldiers firing muskets then fighting with broadswords and defending themselves with round shields called targes.

Despite this victory Charles' army marched further north to defeat at Culloden outside Inverness, the last battle fought on British soil. After six months on the run, Charles set sail for France never to return.

BONNIE PRINCE CHARLIE
Charles Edward Stuart, also known as 'Bonnie Prince Charlie' is one of the most famous characters in Scotland's history. People love him or hate him.

FALKIRK FC
Falkirk FC's 'Highlander' badge was worn by the club in the 1950s. It is best remembered for being on the club's strip in the 1957 Scottish Cup final. It was revived in 2007/08 to mark the 50th anniversary of that famous win.

DID YOU KNOW? One of the most significant battles in British history was over within an hour.

WHY NOT? Wear a bunch of white ribbons, called a cockade, in your hat if you support Prince Charles Edward.

VISIT Experience the powerful emotions of Culloden either by walking out on to the battlefield on the moor or at the visitor centre with its theatre that puts you right at the heart of the action.

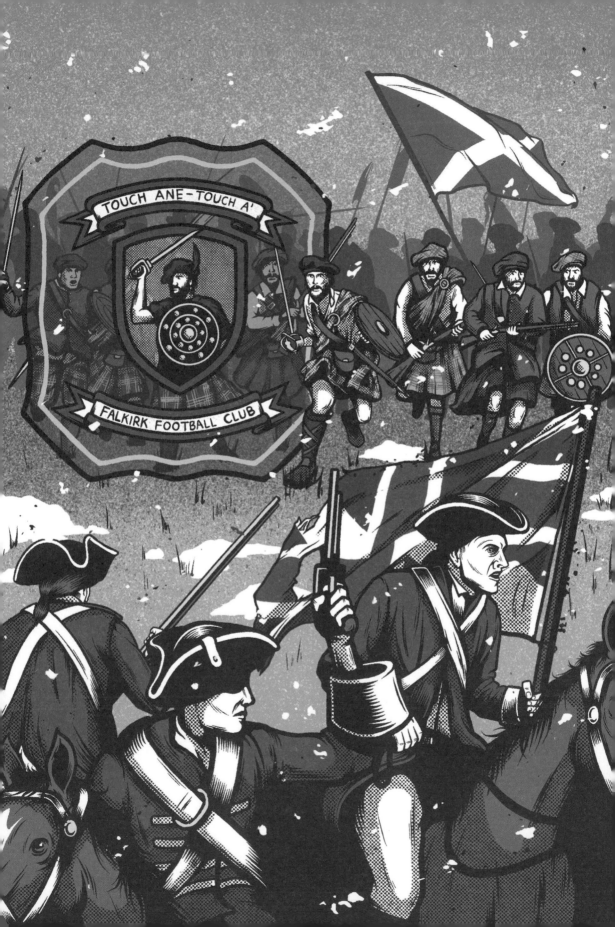

1753

MATCH OF THE DAY

The 1753 Marriage Act made it illegal in England to marry under the age of 21 without parents' consent. The Act did not apply in Scotland where a boy could marry at age 14 and a girl at 12. Young couples ran away together to marry in Gretna Green, the first village north of the border on the river Sark.

Provided two people witnessed the ceremony almost anyone could perform it and Gretna's blacksmiths were thought to be lucky. The last of these 'anvil priests' performed 5,000 weddings before the custom ended in 1940. The blacksmith hit the anvil with a hammer or placed the couple's hands on the anvil to declare them man and wife.

Runaway marriages made headlines in the popular press. One story featured an irate father who claimed that an older woman had drugged his son and carried him off to Scotland to get her hands on his money. In another case the girl's father chased the couple all the way to Scotland in 1782. He cut his daughter out of his will, his fortune passing to his eldest granddaughter.

GRETNA FC
Gretna FC reached the Scottish Cup Final in 2006, and were promoted to the Scottish Premier League the following season. The club, however, fell into financial difficulties and was forced to dissolve in 2008. The club's supporters' trust then decided to establish a new club, Gretna FC 2008.

DID YOU KNOW? If you are travelling from England, to Gretna, you cross the River Sark. This marks the border between England and Scotland. The Sark Bridge is featured on the football club's badge, and was built by Thomas Telford in 1814.

WHY NOT? Design the outfit you might wear at a Gretna wedding.

VISIT The Famous Blacksmiths Shop, and see the anvil, that is featured on the badge of Gretna FC 2008.

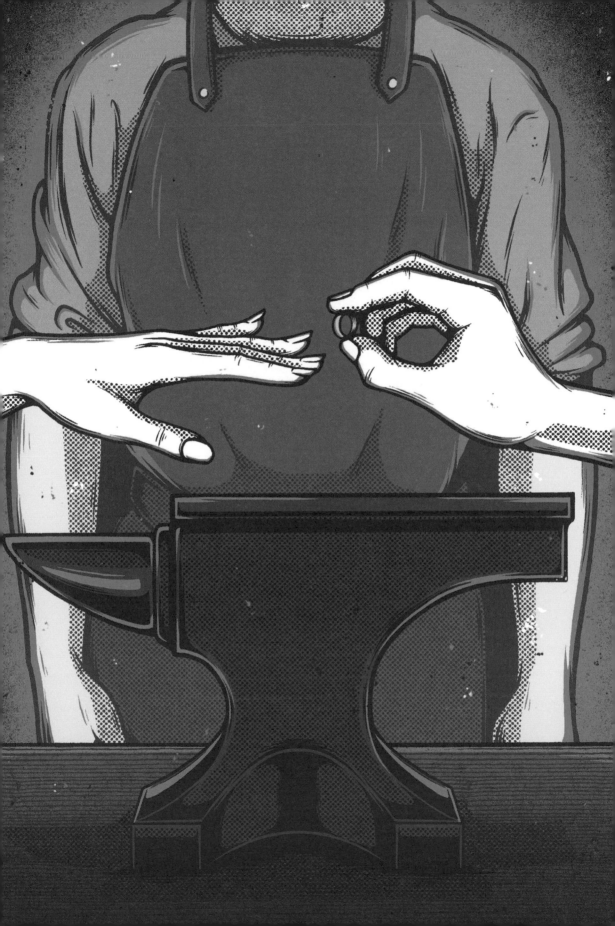

1757

THE MAN WHO GOT BRITAIN MOVING

This year a poor Scottish shepherd's son was born only for his father to die four months later.

Thomas Telford rose from a trainee stonemason to the world's first civil engineer, building roads, canals, harbours and bridges throughout Britain. He held the post of surveyor of public works for the county for nearly 50 years. In 1968 Telford New Town in Shropshire was named after him.

Before Telford, travel in Britain was slow, muddy and dangerous. Roads were owned privately, badly maintained and charged tolls to use them. The fastest way to travel was by coach but horses had to be changed regularly. Every few miles roadside inns stabled horses and catered for travellers.

Telford revolutionised road building. His roads had a gentle slope: they were built on firm foundations and drained properly. His Holyhead Road is still in use and is the pioneer of the modern motorway.

Wellington in Shropshire is a market town on Telford's Holyhead road. At one time it had eleven public houses within a three mile stretch. One was the Buck's Head which gave its name to the town's nearby football stadium and to AFC Telford United's badge of a male deer or buck's head.

AFC TELFORD UNITED
AFC Telford United was formed in 2004 after the original club, founded in 1872, folded due to financial problems.

DID YOU KNOW? The bridge on the badge of the former club is the Iron Bridge that crosses the River Severn. Opened in 1781, it was the world's first cast iron bridge. Today the bridge is celebrated as an icon of the Industrial Revolution and as a UNESCO World Heritage site.

WHY NOT? List the inn and pub names in your town or village. What is the reason behind the names?

VISIT The cradle of the Industrial Revolution at Coalbrookedale in Shropshire.

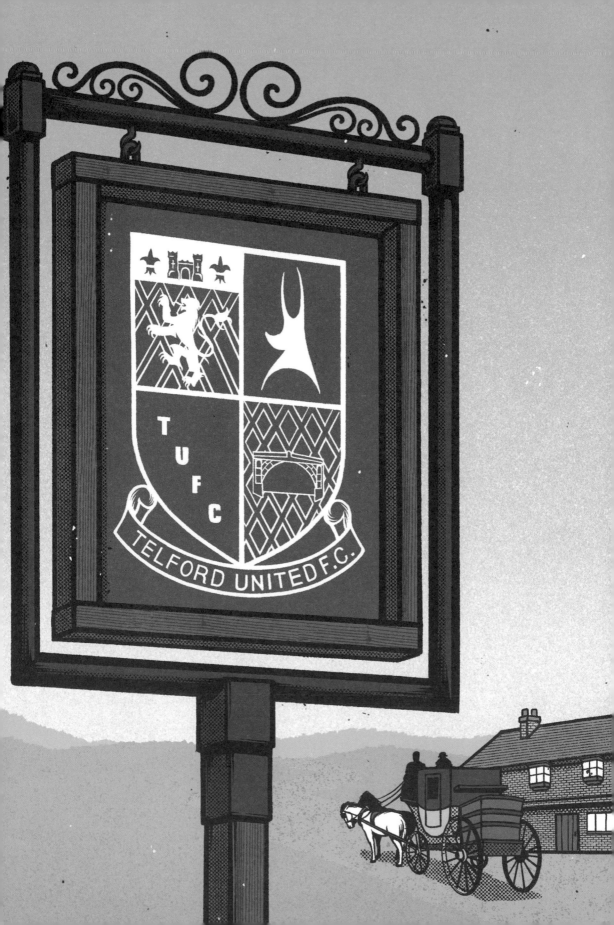

CANAL MANIA

Francis Egerton, 3rd Duke of Bridgwater, had a problem.

How could this wealthy landowner transport coal from his mines to sell to the mill owners of Manchester, eight miles away.?He solved it by building Britain's first canal that did not follow the course of a river.

It was an immense feat of engineering. It involved building an aqueduct to carry the canal over the river Irwell. The Duke's engineer demonstrated how it would work to Parliament by carving a model out of cheese. Tourists flocked to see the new wonder of the age.

These Manchester mill owners had a similar problem. The town was far from the sea so they had no easy way of bringing in cotton or of getting their finished goods to the docks. After many years of argument the canal was extended to join the Mersey upstream from Liverpool docks.

Canal mania exploded all over Britain. Every investor wanted a slice of the action and soon a network of canals covered the country. The arrival of the railways put an end to much of the canal business.

A SHIP AND THREE STRIPES
Manchester United FC's badge in the 1950s featured a ship, diagonal stripes possibly to suggest its three rivers, and red roses for Lancashire.

Manchester City FC's badge today is not dissimilar – the ship, water and the red rose.

CITY OF MANCHESTER
Both badges were inspired by their birthplace. The city of Manchester's coat of arms also has the famous busy worker bees, that recently became a symbol of the region.

DID YOU KNOW? The illustration (opposite) shows engineer James Brindley's marvel of the canal age which opened in 1793.

WHY NOT? Walk along a canal near you. Most have footpaths where horses once towed the barges. They are a great place for wildlife.

VISIT In 1894 the Barton Swing Aqueduct replaced it, taking the Bridgewater Canal across the new Manchester Ship Canal. It is the world's only swing aqueduct.

SAIL AND STEAM

Greenock on the Clyde features a sailing ship on the football badge for Greenock Morton FC although its most famous son, James Watt, never went to sea.

It was while repairing a model of a steam engine, used for pumping water out of mines that James Watt came up with the idea of how to double its fuel capacity. He was thinking about the problem while on a Sunday walk on Glasgow Green. His invention in 1765 was one of the advances behind Britain's Industrial Revolution that changed landscapes and lives forever. People worked in factories rather than at home; goods could be mass produced: the focus of industry moved north to be near natural resources like coal and iron.

It took a few decades for the new steam technology to be applied to ships. A Greenock yard built the first commercial paddle steamer in Europe, the *Comet*, for a local man who ran excursions on the river.

Greenock shipyards built vessels using both steam and sail like the fast sailing clippers which raced to be the first to bring the annual crop of tea from China to London a century after James had discovered the efficiency of steam.

GREENOCK MORTON FC
The club badge is a simple version of the town crest. The ship is a design of 1641, the year when Greenock was granted its charter. It celebrates the town's long importance as a seaport.

DID YOU KNOW? Legend has it that James Watt first realised the power of steam when watching a kettle boiling over on the stove. If he held down the lid firmly it stopped bouncing about and the steam came out the spout.

WHY NOT? Find out how many football club badges feature boats or ships, because shipbuilding or overseas trade were important to the economy.

VISIT *Comet*, which was built in Port Glasgow, the shipbuilding town next door to Greenock. She was Europe's first commercial paddle steamer. A replica of her made by shipyard apprentices now stands in the town centre.

1768
PULLING A PUNCH

The Suffolk Punch is the oldest breed of heavy horse.

All Suffolks worldwide descend from just one horse, foaled in 1768. They are called after one of the richest agricultural counties in Britain whose 'capital' is Ipswich.

Bred to work the land, they pull a punch – strong, sturdy and able to work for long periods without resting. A large farm might once have had over 40 horses and the head horseman was the most important worker.

Farmers had worked the land the same way for centuries. Most grain was still planted and harvested by hand. Farmers used two Suffolk Punches to pull their ploughs and children helped with planting seed. From 1750 methods gradually changed. Landowners created bigger farms with larger fields, enclosing them with fences and hedges. They drained marshes using windmills to pump out the water.

Landowners became interested in applying science to farming to make it more efficient to feed the growing cities. They introduced the Dutch system of planting crops like peas that would enrich the soil rather than leave fields empty to rest between crops. They picked the best of their pigs, horses and cattle to breed and invented machinery to help take the back-breaking labour out of farming.

The Industrial Revolution in the North came hard on the heels of the agricultural revolution. Life would never be the same again.

IPSWICH TOWN FC
In 1972 John Gammage won a competition to redesign the Ipswich Town FC badge. He had discovered that, far from just being a cart horse, it was bred as a war and sporting horse for medieval knights.

One had to concentrate on a familiar object which is exclusive to our county. I immediately thought of the Suffolk Punch.

DID YOU KNOW? The turrets on top of the Ipswich Town badge symbolise Wolsey's Gate. It is all that remains of the school that the infamous cardinal ordered to be built in his home town. As a cardinal and statesman in the government of King Henry VIII, he was almost as powerful as the king himself.

WHY NOT? Guess what the other three breeds of farm animals unique to Suffolk are.

VISIT Meet a Suffolk Punch at the Suffolk Punch Trust farm near Woodbridge in Suffolk.

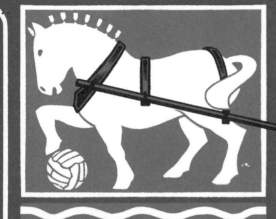

TURNING WATER INTO GOLD

Water put Burton on Trent on the map. This Staffordshire town grew to be the world's most important centre of brewing. Burton's water was uniquely suited to brewing beer, its mix of salts giving a pint its distinctive taste. One of its most famous brands, Bass, moved here in 1777.

Burton beer came into its own in the 18th century when Britain's population doubled. Beer was the national tipple when most water was unfit to drink. As the roads were too rough for beer to travel, most innkeepers brewed their own.

From 1700 ships could sail up the River Trent so brewers could access grain and hops. The opening of the Trent & Mersey Canal put Burton in the middle of a national waterways network with access to ports for export. By 1790 40% of the town's 30,000 barrels a year were exported.

Brewers imported wood from Russia to make barrels and their ships returned with beer for Russia. New markets opened up in the colonies, especially India where the demand for light clear ales that travelled well was strong. The railways gave the British a taste for the new India Pale Ale (IPA). By 1880 nearly one in five of the town's population worked in one of its 36 breweries.

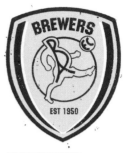

THE BREWERS
Burton Albion FC has no need to put the club name on its badge, just its nickname 'the Brewers'. When the club was created in 1950, it used a tubby footballer whose 'skeleton' was made from Burton Albion's initials, on its programmes. He strode on to the official badge In 1994.

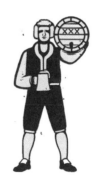

When the club headed for Wembley in 1987, the character was a young brewer clutching a barrel of beer on his shoulder.

DID YOU KNOW? Football was not Burton's first organised game. In 1827 Abraham Bass, son of brewer Michael Bass, helped to set up Burton Cricket Club.

DID YOU KNOW? At one time Burton produced one in four pints of beer sold in Britain.

VISIT If the wind is in the wrong direction you can still smell the hops in Burton, home of the National Brewery Museum.

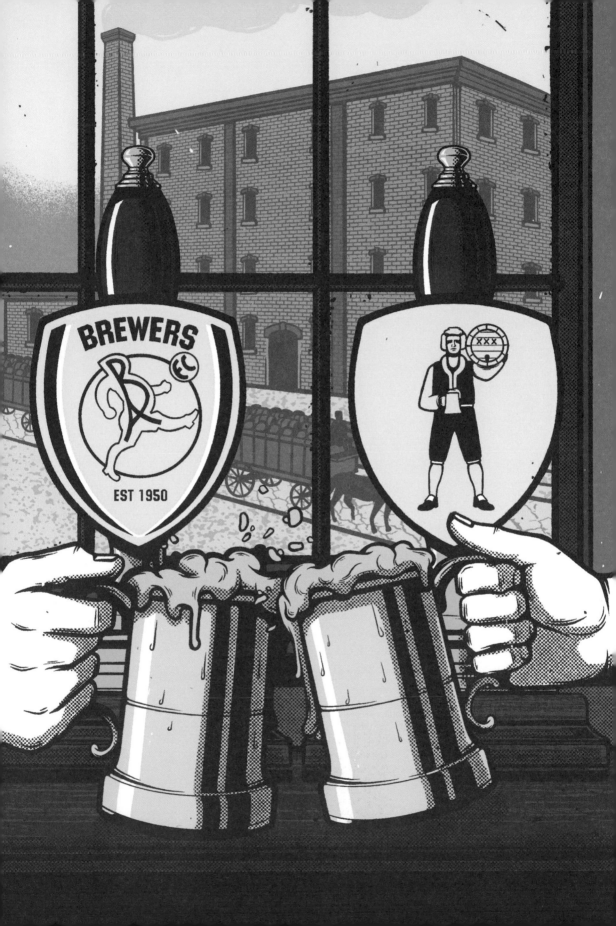

1805

A GREAT ATTACKING FORCE

Although Arsenal FC moved to North London in 1913, its badge has kept the cannon of the works team from the Royal Arsenal, Woolwich south of the Thames, where the club began life.

Working for the most important factory in British history, fifteen men clubbed together to buy a football in 1886. The Gunners were on their way.

George III gave the giant complex his royal blessing in 1805. It had grown enormously in the 18th century with constant power struggles in Europe and revolutions in America and France. The cannon was the weapon of choice both on land and at sea.

Woolwich's site was ideal. Few people lived there and the marshy ground deadened the impact of explosions.

Different departments manufactured cannon and gun carriages, trained men in operating them and stored and tested gunpowder and cannonballs. There was so much activity within the 2.5-mile-long boundary wall that one complex was simply named 'the great pile of buildings'. There were docks, a canal and later Britain's most complex and dense network of railways.

At its peak during the First World War, over 100,000 people worked at the Royal Arsenal. It was eventually closed because it could be attacked from the air.

THE BOROUGH OF WOOLWICH
In 1888 the club adopted its first badge, based on the coat of arms of Woolwich Borough. It featured three cannons with lions at their loading end.

CUP FINAL SPECIAL
The badge has slowly changed over the years. The 1930 FA Cup Final was the first time the side profile of the cannon featured while the 1978 version shown right added cannonballs.

DID YOU KNOW? The word Arsenal means 'a place where weapons and military equipment are stored'.

WHY NOT? Look out for the cannons that guard Arsenal's stadium, The Emirates. You can even visit the club museum.

VISIT In 1932 Arsenal's legendary manager, Herbert Chapman, had the bright idea of changing the name of the tube station next to the Highbury ground from Gillespie Road to Arsenal to raise the profile of the club.

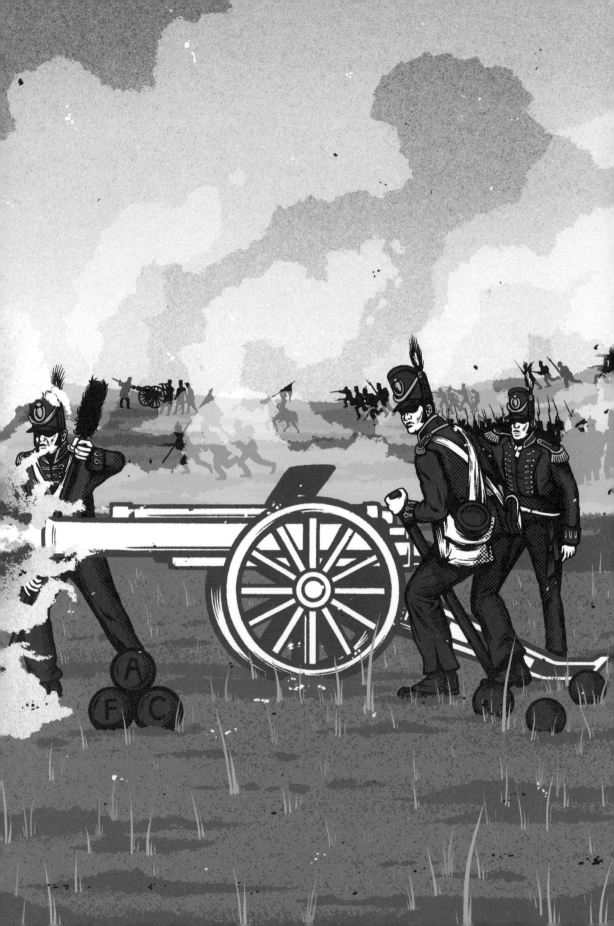

1806
A STRONG DEFENCE

The British built over a hundred gun towers on the south and east coasts of England to defend the island against potential invasion from the sea by Napoleon Bonaparte, from 1806. The shortest crossing of the English Channel was only 20 miles.

Although many in Britain had backed the French Revolution, support turned to anger after the French royal family was executed. Napoleon, a brilliant military leader, seized the opportunity. He declared himself Emperor of France in 1804, acted like a dictator and had ambitions to conquer Britain and much of Europe.

The British defence was the Martello tower, a circular brick building around 10 metres (33 feet) high, the thickest stretch of wall facing the sea. There was a cluster of them round Eastbourne on the Sussex coast. Soldiers entered the tower by a ladder through a door three metres (10 feet) above ground. This floor provided storage including for gunpowder. The garrison of up to 24 men and an officer lived on the first floor and the roof housed a single 24 pound cannon.

People need not have worried. Napoleon never arrived, thanks in part to the defeat of the French and the Spanish navies by Horatio Lord Nelson at the Battle of Trafalgar in 1805. He would have been angry as he did not like his plans being overturned.

EASTBOURNE BOROUGH FC
The club badge features the town's Martello tower that is located south west of Eastbourne Pier. It is known locally as the Wish Tower.

MARTELLO TOWER
The single cannon on the roof, aimed towards the English Channel, and Napoleon.

DID YOU KNOW? Martello towers are so called because they resemble a tower at Mortella Point in Corsica. Surprise, surprise – that's where Napoleon was born!

WHY NOT? Some sports venues in Eastbourne sound very familiar. Eastbourne Rugby Club plays at Hampden Park while Eastbourne United FC plays at The Oval. Find out which other sports ground share a famous name.

VISIT Some towers along the south coast have survived as coastguard stations, look-out points during the two World Wars and more recently as cafes or holiday cottages.

1807
SELLING HUMAN BEINGS

The slave trade in the British Empire ended in 1807 after 20 years of campaigning. Nearly another 30 years passed before slave ownership in the colonies was abolished.

Slavery in Britain had doubled in the 18th century. Merchants and sea captains grew rich on the three-way trade: shipping goods out to Africa, to exchange for humans to be sold as slaves in the colonies and bringing back goods like tobacco and sugar. Stories of how slaves were treated on board ship and on the plantations where they grew the crops increasingly shocked the British public.

At the end of the 18th century three quarters of all European slaving ships left from Liverpool and carried 1.5 million slaves from Africa. Many did not survive the journey.

Liverpool is proud of its seafaring past. From lamp posts to Liverpool Football Club you cannot miss the city's symbol, the Liver Bird. The most famous birds are Bertie and Bella, the statues on the top of the Royal Liver Building. They are attached to its towers by chains in case they blow away but the legend is that without chains they might fly away to freedom. So it is not only the slaves but the birds who were chained.

HUMAN CARGO
These plans for the Brookes slave ship, which was launched from Liverpool in 1781 and made 11 trips from the city, show how the slaves were stowed on board. The ship carried over 600 men, women and children on a voyage which lasted 1-3 months.

The Brookes plans were widely publicised to make the British public aware of the horrors of slavery.

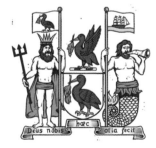

THE BIRTH OF THE LIVER BIRDS
The city of Liverpool coat of arms, 1900 where the Liver Bird began life as a cormorant, a breed of seabird.

DID YOU KNOW? After the slave trade was abolished Liverpool's role in the history of the British Empire continued to grow. Between 1830 and 1930 nine million people sailed from Liverpool, then the largest emigration port in the world. These people were mostly travelling to North America, Australia and New Zealand - the 'New World'.

WHY NOT? Many people in Britain made money from the slave trade in the 18th century. See if you can find someone near you.

VISIT Liverpool's world famous waterfront, now a World Heritage site is overlooked by the Liver Birds, and the nearby International Museum of Slavery on Albert Dock.

1815

A HOLIDAY HOME FIT FOR A KING

1815 was a big year for Britain.

Wellington helped defeat Napoleon at the Battle of Waterloo. Peace was made between Britain and the USA. Jane Austen published her romantic novel *Emma*. George III was still King although the future George IV ruled the country as Prince Regent, after his father was declared mentally unfit to rule.

The Prince Regent, nicknamed Prinny, was very different from his father. He was young, gambled and led a wild lifestyle. He turned Brighton, the seaside resort and home of his favourite uncle, into a place of fashion, frivolity and fun. He could escape there far from the stuffiness of the London court. Brighton became known as 'London by the sea'.

In 1815 he transformed his modest home in Brighton into a fantastic palace with the help of his architect, John Nash. With its domes, the outside was like an Indian palace while the inside was largely Chinese. Nash was also developing new areas of London for the Prince – Regent Street, the terraces round Regent's Park and St James Park. A touch of Gothic here, a Classical pillar there. His light and varied style was called Regency.

Regency replaced the Georgian style when all things Classical were the fashion.

PRINNY
During his Brighton years, George thought nothing of spending his days riding, strolling along the promenade and sea-dipping and his nights eating, drinking, partying and entertaining. His love life, debts and wild lifestyle were a constant source of gossip.

BRIGHTON & HOVE ALBION
The seagull first landed on the badge in 1977, replacing a dolphin.

DID YOU KNOW? Although often referred to as simply 'Brighton', don't forget Hove. For 95 years the club's home was the Goldstone Ground in Hove and its name is still Brighton & Hove Albion FC.

WHY NOT? See how many football clubs you can think of whose names end in Albion, an old name for the island of Great Britain.

VISIT The Royal Pavilion – Prinny's Regency extravaganza with its touches of the Orient.

1817

THE THIEVES' HOLE

A heart in the cobblestones marks the spot where the notorious Old Tolbooth prison stood for 400 years in Edinburgh. It featured in Sir Walter Scott's novel *The Heart of Midlothian*.

Punishment in such prisons was often immediate and cruel, the aim being to hurt the offender. The heads of those who had been executed were displayed on spikes for months as an example to others. People were chained in iron collars and the mob invited to throw rubbish at them for entertainment. Prisoners were tortured to extract a confession.

Conditions in prisons were grim. They housed men, women and children together, often had no toilet nor running water and stank. Prisoners had to provide their own food and furniture if they could afford it and slept on filthy straw or the bare floor. As prisons became overcrowded, inmates were transported to the colonies like Australia.

Newgate Prison in London was famous for its appalling conditions. Quaker reformer Elizabeth Fry was a regular visitor as well as touring Britain inspecting conditions. She campaigned for reform.

The Old Tolbooth was demolished in 1817 not because of its condition but because the building blocked traffic. Cobblestones mark the site of the Old Tolbooth in the shape of the Heart of Midlothian.

THE OLD TOLBOOTH
Prisoners sentenced to death would be held in the Old Tolbooth before being taken on their final journey to the scaffold outside. Can you spot what awaited them in the picture (right)?

HEART OF MIDLOTHIAN FC
The design of the Hearts FC badge features the cobblestones, adding the Scottish saltire and a football.

DID YOU KNOW? Edinburgh used to be part of the county of Midlothian, also known as Edinburghshire, until 1975.

WHY NOT? Find out what other football club features a type of prison on its badge. A clue - think toffee.

VISIT Do as the locals do, if in Edinburgh. Find the Heart of Midlothian and spit on it for luck.

1825
LOCOMOTION NO 1

The Stockton and Darlington was the first public railway to run on steam.

The aim of the railway was to find a way of delivering coal from the South Durham coalfield to the docks at Stockport on the river Tees so that it could be shipped to London.

From 1825 the railway pulled coal waggons along the 25-mile route. Excited crowds gathered to wave it off.

Developing a railway was an expensive business. The person who made the railway happen was a Darlington woollen manufacturer, Edward Pease. Sometimes called 'the Father of the Railways', he persuaded fellow Quakers throughout Britain to invest in the new invention.

George Stephenson and his son Robert designed the track and the first engines. They called them Locomotion No 1, Hope, Black Diamond and Diligence. The speed of the first journey was 8mph, slower than a fit adult can run.

Four years later Robert Stephenson designed the famous Rocket which ran on the world's first intercity passenger line, the Liverpool and Manchester Railway. It won the Rainhill Trials to demonstrate once and for all that steam was the best way forward, achieving a top speed of 30 mph.

EDWARD PEASE
From opening the world's first public railway to driving the meteoric growth of Middlesbrough, Edward Pease and his family made the area an industrial powerhouse.

They also used their fortune and influence to support anti-slavery, animal welfare, peace campaigns and prison reform.

DARLINGTON FC
Darlington features Locomotion No 1 and a Quaker hat on its badge. It's one of the few clubs to feature its nickname rather than the club's name.

DID YOU KNOW? Also known as Friends, Quakers belong to a religious group which dates back to the mid-17th century. They believe in living their lives by the principles of truth, simplicity, equality and peace.

WHY NOT? Find out which other football club has a train on its badge.

VISIT The iconic Locomotion No 1 at Locomotion (National Railway Museum) at nearby Shildon, or see Stephenson's Rocket at the Science Museum in London.

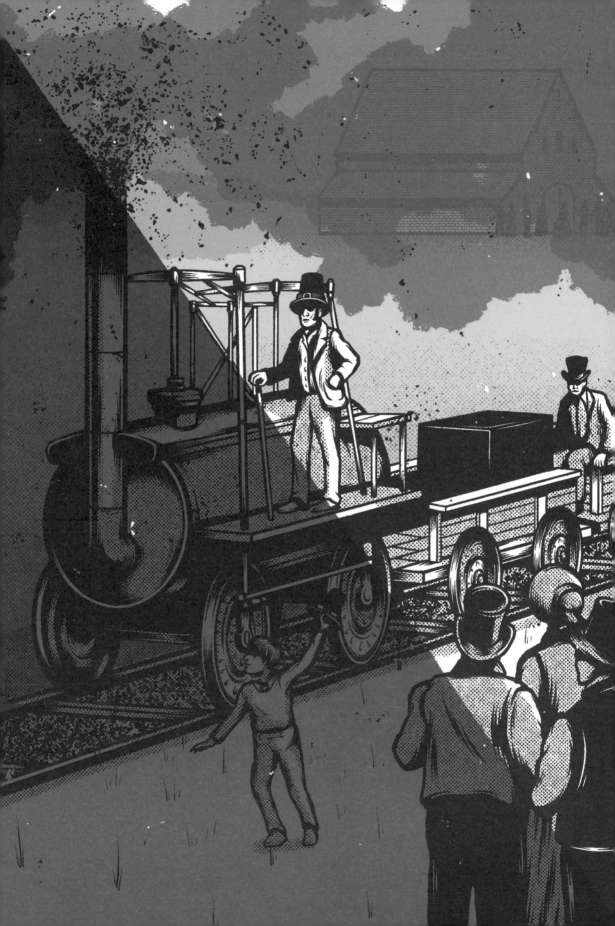

THE VICTORIANS AND BEYOND

NEVER DESPAIR OF WINNING, AND NEVER GIVE UP DOING YOUR VERY BEST TO THE LAST MINUTE OF THE MATCH.

ARNOLD HILLS
FOUNDER OF THE FUTURE WEST HAM UNITED FC, SENT THIS MESSAGE TO HIS TEAM IN 1896.

1837
COME ON YOU IRONS!

1837 was a big year. Young Victoria became Queen and the future Thames Ironworks was founded.

The Victorian era saw the growth of heavy industry. The Thames Ironworks alone made iron bridges, paddle steamers, warships and liners. By 1855 it employed over 3,000 people. It became the largest yard on the Thames and built some of the world's biggest ships.

Think big. The same story held true up and down the country – textiles in Manchester and Lancashire, coal mining in Scotland and South Wales, engineering in Birmingham and shipbuilding on the Clyde and in the North East of England. Industry thrived wherever there was access to water, coal and raw materials. The fast growing British Empire was hungry for goods.

People moved to the cities to be near work but were often forced to live in slums with no drains or water. Canning Town, home to the Thames Ironworks, barely existed until the railway arrived. It then grew dramatically with docklands, chemical works and its shipyard.

In 1895 Arnold Hills, the owner of the Thames Ironworks & Shipbuilding Co, helped found Thames Ironworks FC, the future West Ham United. The team was picked from the workers. Hills believed that his local community of Canning Town should have its own football team and financially backed the club until 1900.

Several of today's top clubs – Arsenal, Manchester United, West Ham – started out as works teams.

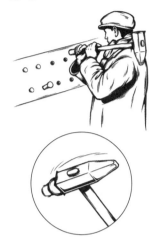

A RIVETER'S HAMMER
A riveter bashed the rivet with his hammer to stitch two pieces of metal together.

WEST HAM UNITED
The crossed riveting hammers on the West Ham badge. Players and fans often make the sign with their arms.

DID YOU KNOW? While the football world commonly refers to West Ham as The Hammers, the club's supporters have always referred to their team as 'The Irons'. The chant 'Come on you Irons' is heard on every match day.

WHY NOT? Find out more about Arnold Hills. He was ahead of his time. He introduced an eight-hour working day, and a profit-sharing scheme for employees.

VISIT Canning Town tube station in East London has a mural dedicated to Arnold Hills and nearby Thames Ironworks, one of whose buildings still survives.

SPREADING THE MESSAGE

In 1843 Henry Cole sent the first Christmas card. It featured his family raising a toast. By the end of the century Christmas cards had become a craze, 11.5 million being produced in 1880 alone.

Life was speeding up in the Victorian era and people looked for any way to make it faster and more efficient. Cole had helped to set up the penny post in 1840. This introduced a standard charge throughout the UK paid for by the receiver rather than the sender with the penny black stamp. Steam ships carried mail across the Atlantic in days rather than weeks. Even faster ways of communication were on the horizon as telegraph poles marched across the land and from 1861 via a cable under the Atlantic. Governors of far-flung outposts of Empire could be in touch with Whitehall in seconds rather than weeks. The telegraph was Victorian email.

The Christmas card has remained the mainstay of the post. Robins first became associated with the festive season because they shared a red breast with the uniform of the postman who delivered the cards. Posties were often nicknamed 'robins'. In the same way the bird is linked to the traditional red strip of Bristol City FC.

BRISTOL CITY FC
By popular demand the robin flew back on to Bristol City's badge in 2019.

A WORLD FIRST
The Penny Black of 1840 was the world's first postage stamp. The portrait of the young Queen Victoria on it did not change until her death when she was over eighty.

DID YOU KNOW? Three other professional football clubs are nicknamed 'The Robins' and all play in red – Charlton Athletic, Cheltenham and Swindon Town.

WHY NOT? List as many football clubs as you can that have a bird on their badge.

VISIT Travel under central London on a mail train as part of your visit to the Postal Museum.

1845
THE GREAT HUNGER

The industrial north was hungry for labour. Increasingly people moved from rural Britain to the new cities and towns.

This move was more than matched by Irish emigration especially during the Famine years of 1845-49 and after. The potato harvest failed for several years, potatoes being the basis of the Irish diet. A million people died during the Famine and a million emigrated, largely to Britain and the USA to escape poverty and to seek work and a better life.

Immigrants were usually forced to settle in the poorest parts of cities like Liverpool and Glasgow and to take the lowest paid work as labourers on building sites and in the docks. The Irish formed their own communities keeping up their traditions of song, storytelling and dance and maintaining their own religion of Roman Catholicism. Their symbols were the colour green, the harp and the shamrock.

Priests and leaders of other religions set up football clubs like Celtic and Hibs to keep young boys off the streets and out of the pubs. In the early years clubs stuck to names like Hibernian, the Latin name for Ireland, to reflect their religious support and country of origin.

HIBERNIAN FC
Hibs' current badge shows the Irish harp as a reminder of the club's roots, Edinburgh castle as an icon of its location and a ship to represent Leith, the city's seaport, from where the club draws much of its support. There have been many changes to the badge over the decades reflecting the wider debate about the fan base now being largely Scottish and non-religious.

CELTIC FC
It is said that the Celtic badge represents, not the Irish shamrock, but reflects the story that before their first game at Celtic Park in 1892, someone found a four-leaf clover growing in the centre of the pitch.

DID YOU KNOW? The original name proposed, Glasgow Hibernian, was rejected in favour of Celtic. Fans pronounced it at first as if it was spelt with a hard K but gradually the softer Irish pronunciation took over.

WHY NOT? Decide for yourself whether the four-leaf Celtic badge is a shamrock or a clover.

VISIT The Scottish Football Museum in Glasgow to see exhibits associated with Celtic's glory years.

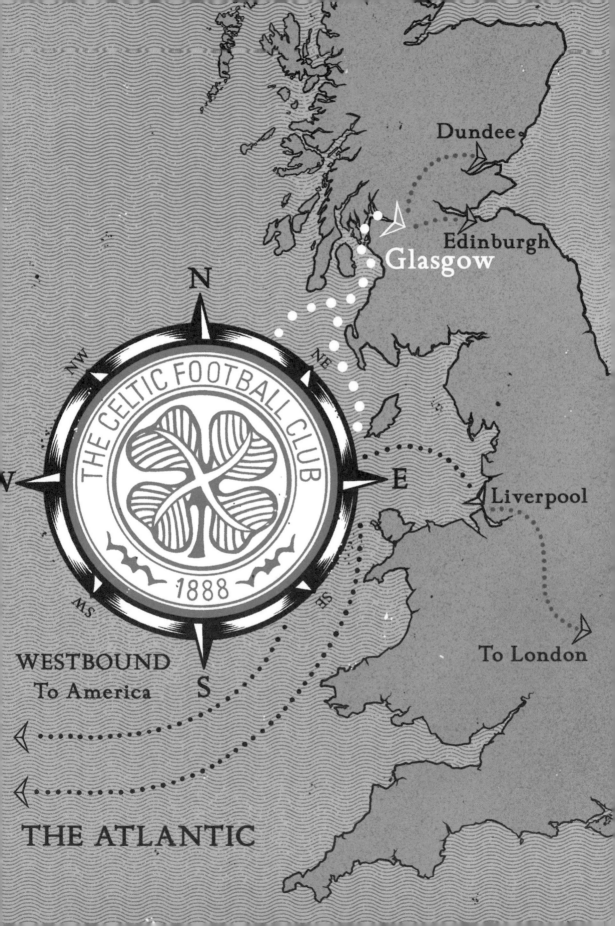

N

NW NE

W E

SW SE

S

Dundee

Edinburgh

Glasgow

THE CELTIC FOOTBALL CLUB

1888

Liverpool

To London

WESTBOUND
To America

THE ATLANTIC

GOING FOR GOLD

The roots of sport as we know it were put down in 1850.

Before the Victorian era sports were unorganised and very different to those played today. The 19th century saw the start of sporting organisations with rules and competitions. The most popular sports were boxing, rowing, horse racing, cricket and athletics. Football and rugby were just starting to become more widely known and played.

People had more leisure time to play games. Teachers and the clergy encouraged sport as morally improving, and healthy, especially in the expanding cities and most schools had an exercise yard. Public schools promoted sports like rugby and cricket but played as amateurs and gentlemen.

Better and cheaper transport meant that people could travel further to compete and watch their team. In 1857 the world's oldest surviving football club was founded, Sheffield FC. It was made up of members of the local cricket team looking for a game to play in winter.

The top sporting event today is the Olympic Games. Its origins go back to 1850 when local doctor, William Brookes, organised the first Olympian Games in the Shropshire town of Much Wenlock. They included football, quoits, cricket, cycling on penny farthings and athletics. Although Brookes was in touch with the Greek organising authorities he died before his dream of an international Olympics came true in Athens in 1896.

ANNAN ATHLETIC FC
In the mid-1970s, the young son of a coach at Annan Athletic designed a badge with a flaming torch in the centre which stood for the 'athletic'. Was he influenced by the Montreal Olympics held in 1976? He became a professional footballer.

RUSHALL OLYMPIC FC
Rushall Olympic (right) first kicked a football in the West Midlands three years before the first modern Olympics of 1896.

DID YOU KNOW? Several football teams have incorporated the word Athletic in their title including Charlton Athletic and Wigan Athletic. Both clubs played their early matches at athletics grounds.

WHY NOT? Find out how your team started out. Wanderers? Rovers? Albion? United? The name may give you a hint.

VISIT Follow the Olympian Trail around Much Wenlock starting and finishing at the Museum.

1851
THE WORKS OF INDUSTRY OF ALL NATIONS

The aim of the Great Exhibition was to show off British manufacturing which was riding on the crest of a global wave. By comparing products with those of other countries visitors could see how good Britain's were.

Over 100,000 objects were displayed along ten miles by over 15,000 contributors. Britain and Empire occupied half the display space. The biggest surprise was the quality and technology of the American displays overlooked by a giant eagle draped in the Stars and Stripes.

The Exhibition was the brainchild of Queen Victoria's husband, Prince Albert. He used the profit made by the Exhibition to fund free museums. Soon every large city wanted its own museum.

The Exhibition was the start of mass entertainment. Six million people from all over the world visited Hyde Park in six months. There were cheap entry tickets and excursion trains from throughout the UK. Many people also had their first glimpse of 'exotic foreigners'.

What really captured people's imagination was the building itself – a gigantic greenhouse of iron and glass, three times the size of St Paul's Cathedral. After the exhibtion the building – nicknamed 'The Crystal Palace' – was moved to South London in 1854. Here the highlight was the world's first dinosaur park where diners could eat inside an iguanodon. The Crystal Palace burned to the ground in 1936 but the dinosaurs survived and can be visited today.

CRYSTAL PALACE FC
The 1960s Crystal Palace badge showed just the side view of the building. In recent times the club has added the Eagle, of its nickname.

THE GREAT LEGACY
The profit from the Great Exhibition allowed for the purchase of 96 acres of land in South Kensington, now known as 'Albertopolis'. Over the next half century the following institutions were established there:

V&A

Natural History Museum

Science Museum

Royal College of Art

Royal College of Music

Imperial College

Royal Albert Hall

DID YOU KNOW? Crystal Palace Park on the slopes of Sydenham Hill in South London has remained relatively unchanged since it opened in 1855 to house the Great Exhibition building from Hyde Park.

WHY NOT? In 2020 a 'World Cup of South London Parks' saw Crystal Palace Park voted the winner. Create your own world cup. What would your subject be?

VISIT The dinosaurs in the park are the world's first ever attempt to interpret fossils as full-scale, living creatures.

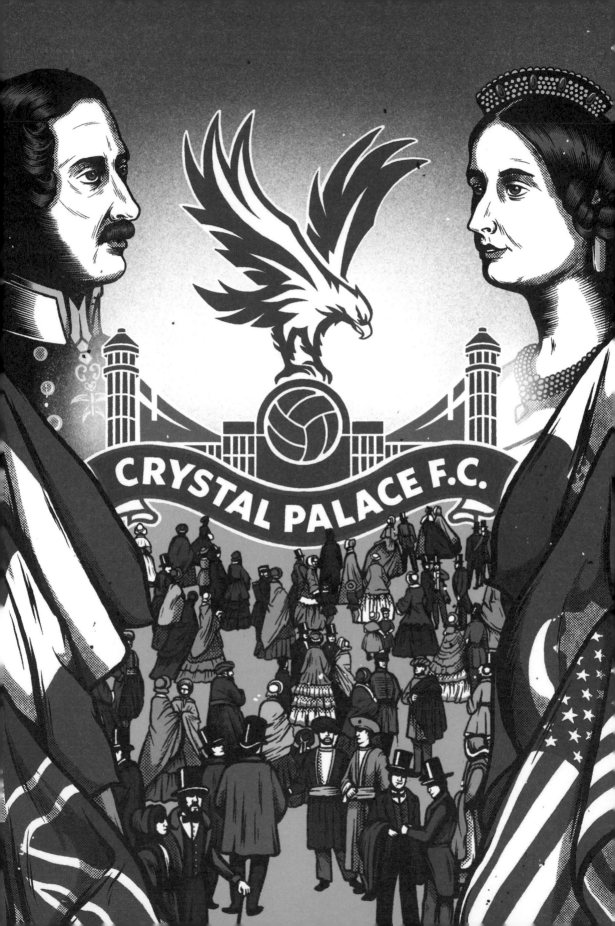

CRYSTAL PALACE F.C.

1856
STEEL TOWNS

1856 was the year that the steel industry was born thanks to the invention of a way of using oxygen to reduce the carbon in iron. Carbon made iron brittle and less easy to work.

Towns like Motherwell in central Scotland and Scunthorpe in Lincolnshire had both grown from hamlets to flourishing iron towns by 1850. This was because they were close to raw materials like ironstone from which the metal could be extracted and the railways. Then along came Englishman Henry Bessemer and his way of making steel. Prices dropped, iron ore could be used from anywhere and the world's appetite for steel rails for railways could be met. Fortunes were made from steel.

Motherwell, Scunthorpe and other places in Britain became steel towns overnight, their skylines dominated by chimneys and cooling towers and the night sky almost as bright as day. They were joined by the new town of Corby in Northamptonshire, known as 'little Scotland' because of the number of experienced Scottish steel men who moved south for work. The process of making steel has changed and the market has declined: an industry which employed nearly 350,000 men in 1951 now has a workforce of a tenth of that.

SCUNTHORPE UNITED FC
Created by a graphic design student in the 1990s as part of a competition for a new badge, the fist clutching an iron girder of Scunthorpe United FC conveys the town's long association with the iron and steel industries.

MOTHERWELL FC
Can you spot the smoking chimneys of the Ravenscraig steelworks on the Motherwell FC badge? The town was nicknamed 'Steelopolis'. Ravenscraig closed for good in 1992.

DID YOU KNOW? Iron and steel - what's the difference?

Iron is used to make steel.

Iron is simply a chemical element that occurs naturally in the Earth. Iron ores are the commonest element in the Earth's crust but they require to be heated to very high temperatures to be useable.

Steel is a man-made alloy that's made by mixing iron and a little carbon together. Other ingredients may be added to make special steels like stainless steel.

WHY NOT? Find three things in your house made of iron and three of steel. What is the difference?

VISIT Summerlee Museum of Scottish Industrial Life in nearby Coatbridge, another town that owed its wealth to iron. Learn about the area's industries from sweets to steel.

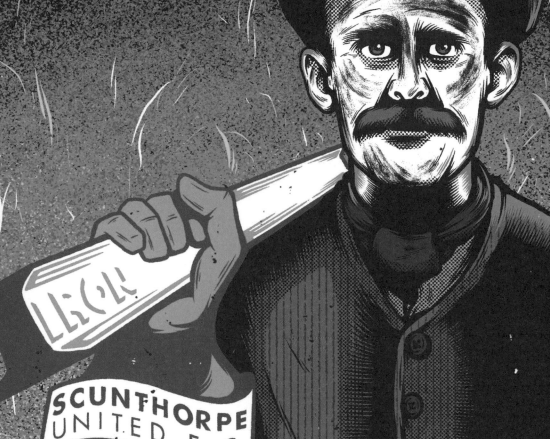

1870
LEARNING WHILE YOU WORK

The 1870 Education Act laid the ground for free education. Thirty years later all children had to attend school until aged 13.

Until then many children of ten or over worked for a living especially in industries where their size and nimbleness was a benefit or tasks were simple. They worked in coal mining, swept chimneys and streets and fixed broken textiles threads. Good employers ran factory schools where they could learn part-time but most did not concern themselves with education. The work was often dirty and dangerous and involved long hours. Children had to work from an early age to help feed large families.

An unusual job for children was plaiting straw to make hats around Luton in Bedfordshire, the centre of the hat making industry. Wheat straws were split and then plaited before the plaits were sewn together to make a hat. A child had to work hard to earn good money: some girls walked as they plaited and most worked from home. Over 10,000 children a year attended special plait schools, as young as three, to learn the trade. These schools were little more than workshops.

Although the straw plaiting trade vanished by the end of the 19th century, Luton's association with the industry stuck. In 1889 the newspapers nicknamed the newly formed Luton Town FC, the Straw Plaiters. In 1994 a straw hat was added to the badge.

STRAW PLAITING
Here's how straw was plaited to make a strip that was then sewn together with other strips to make a hat.

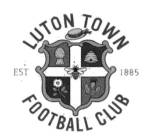

LUTON TOWN FC
Luton has some unusual symbols on its badge. The bee is for industry and the hive for straw-plaiting. The wheat sheaf is for agriculture and the source of wheat straw. The straw-plaiting industry was brought to Luton by a group of Scots under the protection of Sir John Napier of the nearby Luton Hoo estate. The rose comes from the arms of the Napier family and the thistle stands for Scotland from where their ancestors came.

DID YOU KNOW? Around the time Luton Town FC was established in the 1880s, 6,000 women were employed in the town making straw hats and bonnets or plaiting the straw. They would fill over half of the club's current stadium at Kenilworth Road.

WHY NOT? Find out if your club badge or town coat of arms features a symbol of an old industry.

VISIT Wardown House Museum and Gallery on the outskirts of Luton. It has a collection of around 700 pieces of head gear.

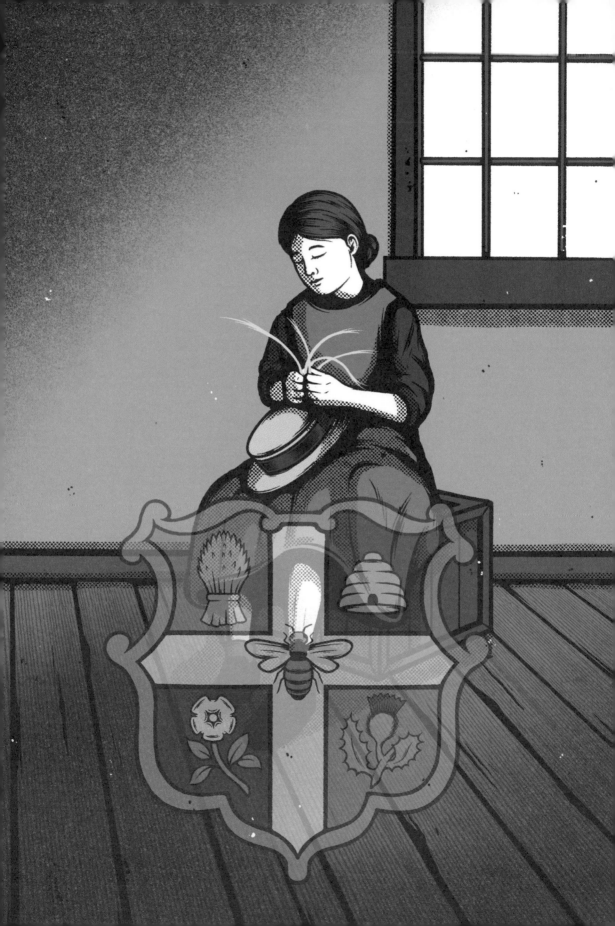

1877
A HIVE OF INDUSTRY

The Industrial Revolution changed the face of Britain from 1750. People moved to find work in the cities of the North.

The proportion of the population living in towns grew from a fifth to three fifths in a century. Workers were roused by the factory hooter rather than the sound of the dawn chorus. Many lived in drab streets of cheap, unhealthy housing, thrown up to cope with the expanding population.

For places like Bury, now part of Greater Manchester, it was all change. Originally a Roman settlement, by the Middle Ages Bury had a castle, a parish church and a market cross. Between 1801 and 1830, Bury's population more than doubled and factories, mines and foundries began to dominate the landscape.

The town acquired the trappings of success, a savings bank, a railway station, its own coat of arms in 1877, and a football club which has largely used the coat of arms as its crest. After the Second World War it was all change again as shopping malls replaced factory chimneys.

Some things do not change. Trading since 1444, Bury Market, world famous for its black pudding, now attracts shoppers from Manchester and beyond. Despite the demise of its official football club, there is a new, fan-led organisation, Bury AFC, which plans to play in one of the world's oldest grounds, Gigg Lane, Bury FC's home since 1885.

Like the bees that symbolised Victorian workers, Bury AFC and its supporters are busy rebuilding their club.

BURY AFC
The football club has kept most of the symbols of the town's coat of arms, many relating to the local industry.

The anvil is for the town's iron forges.

The crossed shuttles are for weaving.

The plant is the papyrus, used in papermaking.

Can you spot the busy bee? It is buzzing between two cotton plants.

The busy worker bee was a popular Victorian symbol for industry.

The badge also features a monument to Sir Robert Peel, twice British Prime Minister who was born in the area.

DID YOU KNOW? By the middle of the 19th century, Britain was producing half the world's cotton cloth, yet not a scrap of cotton was grown in Britain.

WHY NOT? Draw a coat of arms for your nearest town featuring its main industries past and present.

VISIT Bury's art museum was established in 1897 with the gift of the Wrigley Collection, which included over 200 oil paintings, watercolours, prints and ceramics collected by local paper manufacturer Thomas Wrigley.

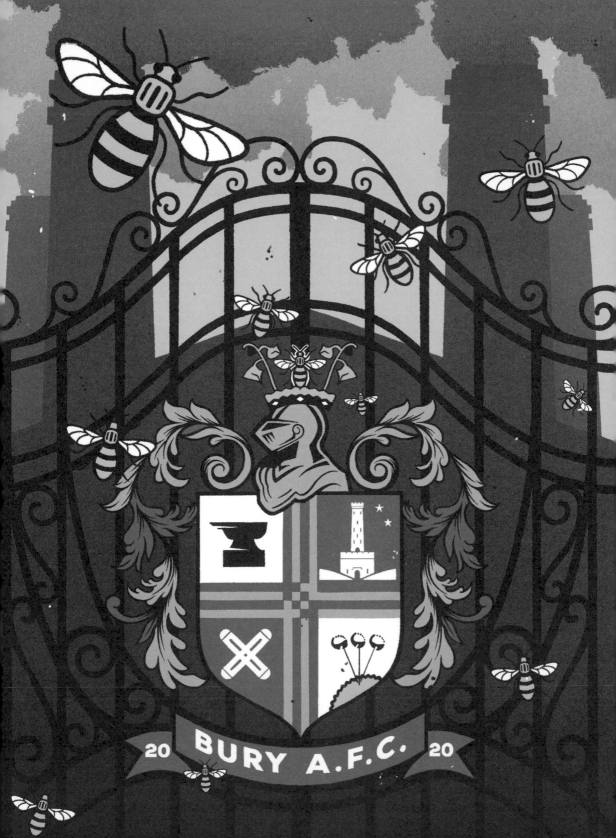

1886
MEET SKIPPY THE YORKIE

Hunting dogs and mousers had been put to work for centuries but it was only in the Victorian era that new breeds emerged as pets.

People had more time to spend on hobbies. Competitions and shows for everything from growing the largest marrow to flower arranging were all the rage.

Queen Victoria set the trend in pet dogs with terriers, a spaniel and a cluster of Pomeranians following at her feet. Yorkshire terriers were bred for their 20 centimetre (eight inch) long fringe of soft silky hair that had to be tied with a bow to allow them to see.

After a job selling 'dog cakes', young Charles Cruft managed the First Great Terrier Show in 1886 and expanded it to become the first dog show for all breeds in 1891. It attracted 36 breeds and nearly 2,500 exhibitors. It grew to become the ultimate dog show, the most famous in the world today, still called Cruft's. In 1997 a Yorkshire Terrier won best in show.

Skippy may be the only dog to feature on a football badge when the six-year-old was chosen in 1969 to represent a new image for Huddersfield Town FC. Yorkies may be small but they are fierce.

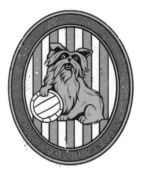

SKIPPY THE YORKSHIRE TERRIER

In 1969 Huddersfield Town wanted something to capture that true Yorkshire grit and determination. Enter Skippy the Yorkshire Terrier. She was a real dog belonging to Mr Colin Fisher who owned the sweet shop on the corner at Honley Bridge traffic lights close to the ground.

She would make appearances in the club shop and even had her own signed photographs. Fifty years on, fans are still as loyal to her as ever although her identity has been redrawn and changed on the badge.

DID YOU KNOW? Skippy is just one of many mascots that Huddersfield Town have trundled on to the pitch since Billy the Goat made his first appearance in 1910. They have included an Aladdin's lamp which was rubbed for luck, a stuffed donkey and Terry the Terrier who has appeared on BBC TV.

WHY NOT? Ask a friend with a dog what the history of its breed is.

VISIT Sadly not all pets have a happy life like Skippy. Some are lost and others are abandoned. Meet the animals at Battersea Dogs & Cats Home in south London and discover how it has cared for over three million animals in its 160-year history.

the Terrier News

1886

SHOCK!! TOP FOOTBALLERS NOW EARN £1 A WEEK

Less than a year after the Football Association changed the rules to allow clubs to pay players, Blackburn Rovers were paying their stars £1 a week.

SHOCK!! RECORD TRANSFER FEE - FOR A YORKIE

Champion Conqueror is small enough to be carried about in a glass case, the size of a cigar box. After winning 58 first prizes he was bought by a Mr Emmett for his wife who collects small dogs.

FOOTBALL RESULTS FA CUP QUARTER FINAL

Brentwood 1 - 3 Blackburn Rvrs
Small Heath All. 2 - 0 Redcar
South Shore 1 - 2 Slough Swifts
WBA 6 - 0 Old Westminsters

RUGBY IN HUDDERSFIELD

This year marks the 10th Anniversary of the five clubs playing Rugby Union football in Yorkshire - Bradford, Huddersfield, Hull, Leeds and York - presenting the Yorkshire County Committee with a cup to be awarded to the winner of their annual competition.

THE MOST EXCITING NEW SHOW OF 1886

FIRST GREAT TERRIER SHOW

Brought to you by Charles Crufts

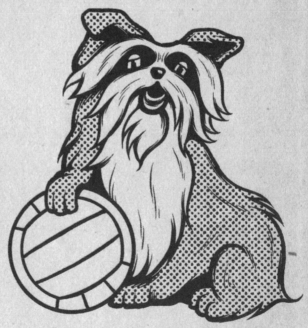

Prizes for the best ball tricks

£2,000 IN PRIZES

WISH YOU WERE HERE

Blackpool Tower sums up British seaside holidays. Opened in 1894, the tallest manmade structure in the British Empire was soon known as 'Wonderland of the World'.

Britons have loved the seaside at least ever since King George III discovered the health benefits of sea bathing. With increased leisure and fast rail transport in the 19th century, the middle classes took day trips or longer holidays by the sea. Blackpool became the world's first working class seaside resort and by the 20th century there were over 100 resorts along Britain's coasts from Southend to Llandudno.

The increasing popularity of the car opened up new destinations such as the former fishing villages of Devon and Cornwall. British holiday resorts remained popular until the 1960s when many failed to compete against Mediterranean package holidays with their cheap booze and guaranteed sunshine.

Although football was not on offer during the peak holiday period, most larger coastal towns had their football club, their badges adorned with shrimps, waves and seagulls. In 1979 Blackpool adopted a modern design based on the Tower but recently has returned to the traditional town crest with its waves, seagull and unusual thunderbolt as a mark of Blackpool's famous electric trams.

Blackpool Tower
1894
158 m high
(518 feet)

Eiffel Tower
1889
312 m high
(1,024 feet)

FROM PARIS TO BLACKPOOL
Inspired by the Eiffel Tower in Paris, Blackpool Tower is 158 metres (518 feet) tall and is now the 120th tallest freestanding tower in the world.

DID YOU KNOW? Over three thousand people visited the Tower on its opening day on 14th May, 1894.

WHY NOT? Can you spot the two seagulls in the illustration? One has escaped from an old badge of the 1980s and the other features on the current badge.

VISIT From its early days Blackpool had ferris wheels, thrill rides, magicians, singers and comedians, not to mention candy floss and the famous Blackpool rock. It now has the UK's highest roller coaster, The Big One, which is 65 metres (213 ft) tall and its only museum dedicated to seaside fun.

1901
DEATH FROM BELOW

This was the year when the Royal Navy ordered its first submarine, HMS *Holland 1*. It was also the year that Barrow AFC was formed.

The submarine was designed by an Irish-American inventor but built in secrecy at Barrow-in-Furness on the Cumbrian coast. She made her first dive in 1902.

The submarine was state of the art technology and the Royal Navy ordered five. By now Britain was engaged in a deadly and costly naval arms race with her rival Germany which lasted until the outbreak of the First World War in 1914. Britain ruled the waves and needed a strong navy to protect her trade and Empire interests. The naval jockeying for power reflected a wider balance of power as France, Britain and Russia allied against Germany and Austro-Hungary.

By the time war broke out, submarine technology had moved on so quickly that the first vessels were out-of-date. With over 50 submarines, Britain had the world's largest fleet. The Germans had 48 submarines, the U-boats that caused such damage to shipping in both World Wars.

Since 1901 the Barrow shipyard has built most Royal Navy submarines switching to nuclear power when HMS *Dreadnought* went into service in 1963. It remains an important employer in the town.

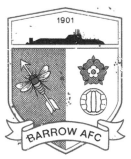

BARROW AFC
Like many clubs, Barrow took inspiration for its badge from the town's coat of arms but the vessel has changed from a steam ship to a nuclear powered submarine.

DID YOU KNOW? A naval periscope allows a submariner to search visually for nearby targets and threats on the surface of the water and in the air, when the submarine is underwater. The technology is as old as the submarine.

WHY NOT? The bee and the arrow on the badge create the word B-ARROW! But find out why there is also a red rose.

VISIT Visit the Dock Museum in Barrow to find out more about the 500 ships and 300 submarines built at the shipyard.

1901

BARROW AFC

1904

A1 PLAYTHING OF THE RICH

By 1900 around 1,000 cars were being driven on Britain's roads, a figure that reached 132,000 by the outbreak of the First World War.

More cars meant more traffic and more accidents. In 1904 the Government introduced the number plate which all cars had to carry, to identify individual cars.

Earl Russell was so desperate to acquire the plate A1 that he camped all night outside the London County Council offices. He was top in line by five seconds. At first if a driver moved to a different council area, they were issued with a new number.

Lots of small engineering companies and cycle manufacturers tried their hand at making cars. One that did not go broke was the Vauxhall Ironworks which produced its first car in the South London suburb of Vauxhall in 1903.

Cars had to wait until 1963 to have their own football club. A works team kicked off shortly after the opening of the Vauxhall Motors plant at Ellesmere Port in Cheshire. Vauxhall Motors FC has the same badge as that of Vauxhall Motors, a griffin.

VAUXHALL MOTORS FC
The badge of Vauxhall Motors FC has kept pace with several redesigns of the car marque, the latest being in 2019.

DID YOU KNOW? Plymouth Argyle to Newcastle United is the longest away trip in English football, 400 miles. Driving could take eight hours or more.

WHY NOT? Look at the badge on your car. Do you know what it might symbolise?

VISIT Check out the date of the annual Vauxhall Heritage Centre open day in Luton, where the history of the company is displayed through its vehicles.

THE WORLD WARS

IF A FOOTBALLER HAS STRENGTH OF LIMB, LET THEM MARCH AND SERVE IN BATTLE.

SIR ARTHUR CONAN DOYLE
CREATOR OF SHERLOCK HOLMES AND ONE OF
MANY OPPONENTS TO FOOTBALL CONTINUING
DURING THE FIRST WORLD WAR.

1914
SIGNING UP

Most competitive sport stopped at the outbreak of the First World War but the Football League played the 1914/15 season unless clubs chose to release players from their contracts.

There was much debate in the press and Parliament. Some people felt that watching football would be light relief for those at home while others thought that footballers should provide a role model to persuade civilians to volunteer.

A special Football Battalion was set up at the end of 1914 attached to the Middlesex Regiment partly as a response to public outrage. Within weeks it was full, many of its 600 recruits being supporters. In Edinburgh 16 Hearts players swapped football for army boots, giving McCrae's Battalion a glamour that no other army unit possessed.

Walter Tull was one of the most remarkable players to join the Football Battalions. Born in Kent to a Barbadian father and English mother, he played for Clapton, Spurs and Northampton Town before signing up. He was rapidly promoted, becoming the first black officer to lead white troops into battle despite military rules banning 'a person of colour' from becoming an officer. In 1918 he was killed crossing no-man's land.

His body was never found.

FOOTBALLERS' BATTALION
Members of the Footballers' Battalions wore special badges on their caps to show what regiment they belonged to.

MILITARY CROSS
The Army praised Walter Tull for 'gallantry and coolness' in leading his company of 26 men to safety in Italy. Many thought that he should have received a Military Cross, the highest award for bravery in the British Army. In this portrait, we decided to grant him the Military Cross as we think that he deserved it.

DID YOU KNOW? Walter Tull's father's father was a slave in Barbados. Walter's parents died when he was a child so he ended up in an orphanage.

WHY NOT? Design a medal for your top hero.

VISIT Walter Tull has been belatedly honoured for his achievements:

Northampton Town FC erected a memorial wall to him in its garden of remembrance at Sixfields Stadium.

A statue to him stands outside Northampton Guildhall.

There is a blue plaque on his former home at 26 Queen Street, Rushden.

In 2014 a plaque was unveiled at 77 Northumberland Park, London N17, on the site of the house where he lived.

There is a statue of Walter in Downhills Park near his home in Tottenham.

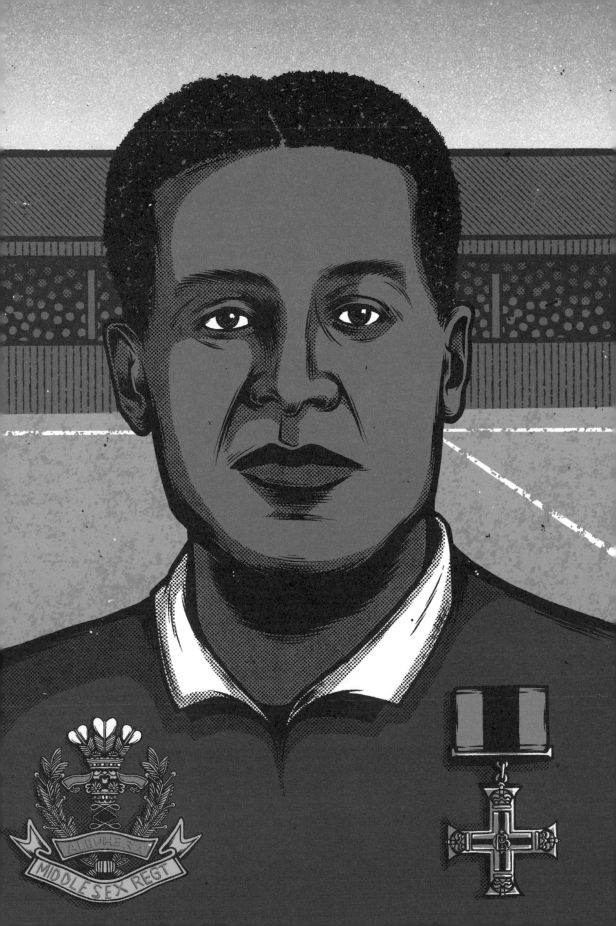

1918
THE ULTIMATE GOAL

In 1915 Clapton Orient, now Leyton Orient, joined the original Footballers' Battalion. In total 41 players, officials and supporters signed up, the first English team to join in numbers.

They travelled to the poppy fields of Flanders where in 1916 three players died during the Battle of the Somme. In 2011 Orient supporters erected a memorial near the Somme to the players, staff and supporters who died during the First World War.

The Battle of the Somme was a bitterly contested stalemate that lasted nearly five months with British and French troops trying to break the deadlock of the trenches. A million troops died in the fighting. The Battle did help turn the tide of war, giving untrained troops and inexperienced officers new tactics. Military innovations included the first use of tanks and poison gas.

By 1918, Britain was exhausted. Around 700,000 families had at least one empty place at table and countless men returned broken in limb or mind. Civilians had experienced bombing and the economy was on its knees.

Many women, however, had escaped housework to find new freedom in factory work and playing football, women's teams in arms factories attracting large crowds. In 1918 women over 30 won the vote.

REST IN PEACE, BOYS

MCCRAE'S BATTALION GREAT WAR MEMORIAL

The Battle of the Somme was technically a British victory although troops only managed to capture a strip of land six miles deep and 20 miles long.

In 2004 a cairn was put up to all the men of McCrae's Battalion at Contalmaison on the Somme, to ensure that the men's sacrifice would not be forgotten. Supporters of Hearts and many other teams from central Scotland including Hibernian, Raith Rovers and Falkirk contributed to the memorial which features the Heart of Midlothian badge.

DID YOU KNOW? On Christmas Day, 1914 a truce was declared that both sides would not fight. Among the many stories about this event was that the two sides played football against each other.

WHY NOT? Read some First World War poetry. Canada's John McCrae was a surgeon working on the front line. He wrote "In Flanders Fields", a poem written from the point of view of fallen soldiers whose graves are overgrown with wild poppy flowers. *"In Flanders fields the poppies blow, Between the crosses, row on row."* His poem made the poppy famous as a symbol of the war.

VISIT Find your nearest war memorial to discover who did not come back and if any shared your family name.

LEYTON ORIENT MEMORIAL

The memorial near the Somme carries the current Leyton Orient badge. The last words of one of the three Orient footballers killed were: *'Best regards to the lads at Orient.'*

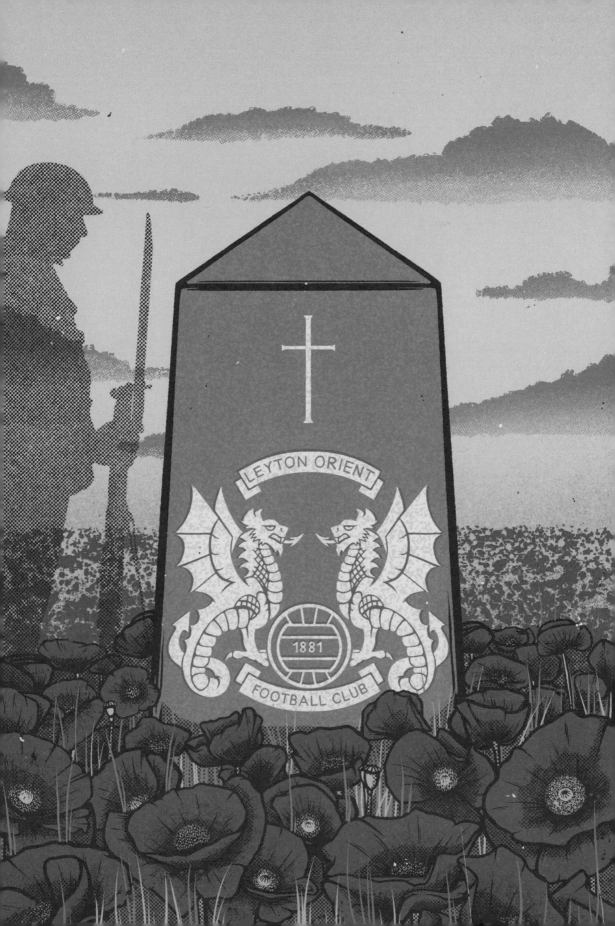

1938
PREPARING FOR WAR

In May 1938 the first production Spitfire flew from Eastleigh Airport outside Southampton.

Until 1939 Britain was divided between those who wanted the country to be put on a war footing against Germany and those who favoured staying out of any European war. Hitler's invasion of Poland ended the debate.

With its powerful Rolls-Royce engine and eight machine guns the Spitfire was the warhorse that, along with Hurricane fighter planes, and new radar technology, saved Britain during the Second World War. It was the first war where the winner would be the power that controlled the skies. By summer 1940 the RAF stood alone against the might of the German Luftwaffe. For over three months the Battle of Britain raged in the skies south of London overlapping with the bombing of UK cities during the Blitz.

The RAF could not get enough Spitfires. When the Southampton factory making them was bombed production moved to garages, bus depots and laundries. Here aeroplane parts were made for assembly at airfields all over the country. Much of the work was done by unskilled women and boys. The public loved the Spitfire, raising funds to produce more. The race against time was won on 7th September 1940 when production first exceeded losses. By 1945, over 22,000 Spitfires had been built.

THE SPITFIRES
Although Eastleigh has a long association with Spitfires, one didn't land on the town's football club badge until recently. In 2020 Christopher Payne, a designer who specialises in creating football club identities, worked with the Eastleigh FC directors, to bring the football club's popular nickname to life.

WORLD RECORD FEE!
Spitfires continue to set records. After 40 years buried under a French beach, a carefully restored Spitfire sold for a world record £3.1million at auction. All proceeds went to charity.

DID YOU KNOW? Eastleigh Airport was home to the final assembly of the Supermarine Type F37/34 Spitfire once the aircraft parts had been built in nearby Woolston. The aircraft's maiden flight, piloted by 'Mutt' Summers, and watched by designer, R.J. Mitchell, took place at Eastleigh.

WHY NOT? Watch a war film featuring the Battle of Britain or the Blitz.

VISIT Look out for a Spitfire or a replica at your local aircraft or military museum. At least 60 are still airworthy.

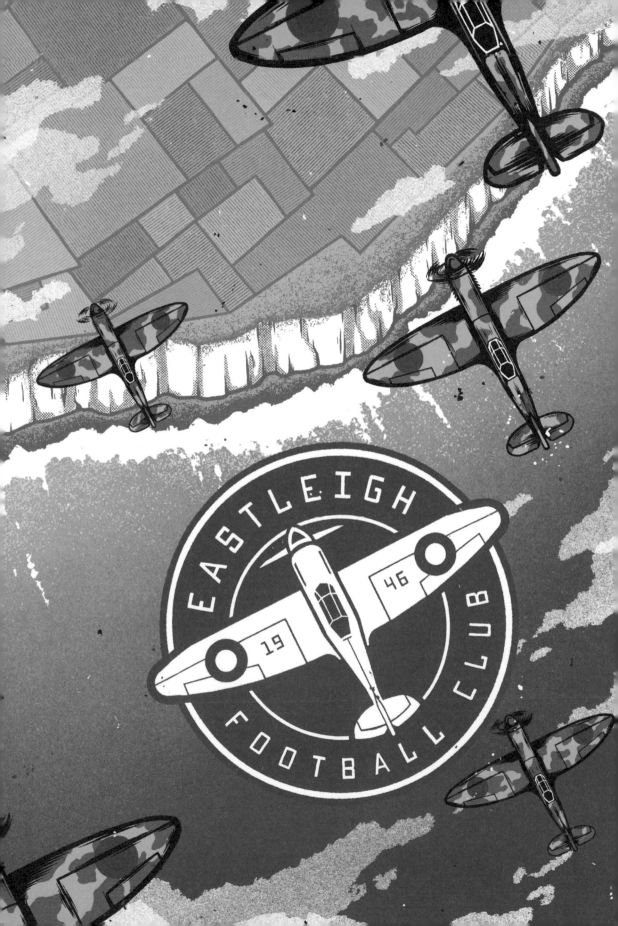

1945
THE PEOPLE'S WAR

The Second World War was the first 'people's war'.

Everyone experienced the impact of bombing from travel difficulties to shortages of goods. Most were called up to fight or look after the home front. About 70,000 ordinary people lost their lives during the Blitz, the seven-month battle to control the air.

The air raid on Coventry on the night of 14th November 1940 was the single most concentrated attack on a British city. The raid lasted 11 hours and involved nearly 500 German bombers. The aim was to knock out Coventry as a centre for war production and to avenge a British attack on Munich.

Coventry had also been picked out because of its historic city centre. Its cathedral was the only one in Britain to be destroyed. More than 550 people were killed and over half of the city's housing, 43,000 homes, was destroyed.

The decision to rebuild the cathedral was taken the next morning. Phoenix-like it arose from the ruins. The phoenix is a legendary bird, born again from the ashes of an ancestor. Associated with the sun and fire, it is a popular symbol of renewal. It was used by Coventry as a symbol for its coat of arms: its University and its football club also adopted it.

DID YOU KNOW? Demolition crews had to be prevented from pulling down the Cathedral tower. They did not realise that it had been leaning for at least 100 years.

WHY NOT? Find a building that was bombed in your nearest city and what replaced it after 1945.

VISIT Part of the bombed cathedral that you see in the illustration still stands today as a reminder of the devastation of war. The cathedral built alongside it was designed by Sir Basil Spence, in a contrasting, modern style and is strikingly different.

BOMBED!
Football grounds were not immune from enemy attack. Those which experienced serious bomb damage included:

Birmingham City
(St Andrew's)

Charlton
(The Valley)

Everton
(Goodison Park)

Ipswich Town
(Portman Road)

Manchester United
(Old Trafford)

Millwall
(The Den)

Norwich City
(Carrow Road)

Nottingham Forest
(City Ground)

Notts County
(Meadow Lane)

Plymouth Argyle
(Home Park)

Sheffield United
(Bramall Lane)

Southampton
(The Dell)

Sunderland
(Roker Park)

West Ham
(Upton Park)

Stirling's **King's Park FC**'s Forthbank stadium was so badly destroyed by bombing that it had to be demolished and the football club closed for good shortly afterwards to be replaced by Stirling Albion.

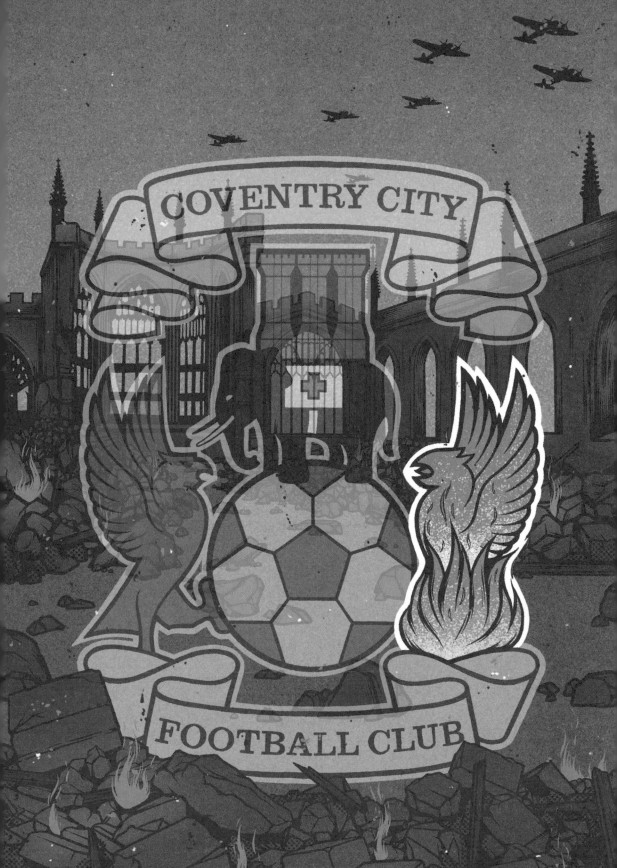

RECENT TIMES

WE BOTH STARTED OUR CAREERS MINING FOR COAL AND CAME UP WITH SILVER.

BILL SHANKLY
LIVERPOOL FC MANAGER ON CELTIC'S JOCK STEIN.

1946
TAKING TO THE AIR

Flight revolutionised the 20th century but it is difficult to choose a date – 1918 when the RAF was established, 1919 which saw the first scheduled passenger flight, from London to Paris or the first transatlantic passenger service in 1939?

In 1946, the same year that Heathrow Airport opened for business, a factory on the Welsh-English border set up a works football team. The factory had been opened to build Wellington and Lancaster bombers during the Second World War. Britain built over 6,000 aircraft in the second half of the 20th century including famous names like the Comet and the Viscount. Under various owners, the Broughton site thrived, making 1,000 aircraft wings and now employing 6,000 workers.

Another football club, Crawley Town FC, also celebrates its flying connections on its badge along with its very own 'red devil'. There is a diamond with three arrows in the top left-hand quarter of its crest. The diamond is the surrounding business area - Gatwick Business Diamond - and the arrows are the planes taking off from nearby Gatwick Airport, pointing to all corners of the globe.

THE WINGMAKERS
The stadium of Airbus UK Broughton, sits within the factory grounds.

THE RED DEVILS
The Crawley Town badge today. Maybe in the future the Crawley red devil will have planes taking off from its fork. Stranger things have happened in football.

DID YOU KNOW? Crawley Town are the original Red Devils. They wear a red kit, and the story goes that to celebrate victory in the 1925/26 Montgomery Cup, a supporter knitted a Red Devil doll. The mascot was taken to the 1927/28 Sussex Intermediate Cup which the club won and adopted the character.

WHY NOT? Find out what the Latin motto for Crawley Town FC – Noli Cedere – means.

VISIT The Gatwick Aviation Museum at Gatwick Airport and see the aircraft of the classic period of British manufacture. Some of the aircraft may even be fitted with wings from Broughton.

1947
A NEW START

Bomb damage had not only destroyed two million houses but revealed how many people already lived in overcrowded slums with no indoor toilets or baths.

In 1945 the Government explored the idea of creating New Towns as centres for growth. Today over two million people live in a British New Town.

Stevenage in Hertfordshire was the first place to plan a New Town in 1947.

Not all New Towns were new. Although some were built on open farmland, Stevenage traced its history back to Saxon times. New industries moved in attracted by good transport links. As with most New Towns facilities were slower to arrive but by the 1980s Stevenage had a hospital, a leisure centre and a swimming pool.

A sign of a successful New Town was to have its own football team. Some authorities even built new stadia to lure established teams to move. Stevenage already had a team dating from 1894, the present club being founded in 1976.

The six stripes on Stevenage FC's badge represent the original six neighbourhoods of 10,000 people who shared Britain's first pedestrianised town centre. The hart comes from the two beasts that support the arms of Hertfordshire.

STEVENAGE FC
The Hert in Hertfordshire stands for a hart, a male deer. Herut was the Old English spelling. In Saxon times Stevenage was called Slith or strong oak. It flourished by trading with London as several Roman roads ran nearby. The landscape was a mix of farm and forest where deer roamed.

HERTS AND HERTFORDSHIRE
The coat of arms of the county of Hertfordshire.

DID YOU KNOW? Stevenage FC finally came of age in 2010 when it joined the Football League.

WHY NOT? Design a football stadium or badge for a New Town.

VISIT A designated New Town. There are over 30 to choose from up and down the UK including Crawley, Hemel Hempstead, Harlow, Peterlee, Basildon and Corby.

YOU'VE NEVER HAD IT SO GOOD

Conservative Prime Minister Harold MacMillan adopted this slogan in 1957 to appeal to voters coming out of the drabness of post-war shortages and rationing.

While most of the older generation enjoyed the comforts of a good wage packet, a modern house and consumer goods like fridges and televisions, the younger generation rebelled against the values of their parents.

Many influences came from the USA shaped by the media and the marketing men. In music, there was rock, punk and soul. In clothes it was drainpipe trousers, followed by the mini-skirt and the uniform of denim. Fashion was bright and colourful and the place to hang out moved from the dance hall to the coffee bar. Every teenager wanted a record player and a transistor radio.

Young people were about more than their image. They protested against the injustices they saw in the world, campaigning for rights for women, the LGBT community and people of colour, as well as taking a stand against the Vietnam War and nuclear weapons. They increasingly showed their loyalties by wearing badges on their denims.

By the early 1970s badges were a fashion statement. Forward looking football managers followed the trend, looking for a bright new image to reflect their hopes for the club. Out went coats of arms and in came cleverly designed graphics based on the club's initials.

RADICAL REVIE
In 1973 Leeds United FC was riding high. Dynamic manager, Don Revie replaced the owl on the badge taken from the city coat of arms with a play on the letters LU. Fans liked it and nicknamed it 'the smiley' badge. It is still fondly remembered.

SMILE!
The smiley face was created by American graphic artist Harvey Ross Ball in 1963.

Ball was asked to create a symbol to raise morale among the employees of an insurance company.

DID YOU KNOW? Football was traditionally played on Christmas Day, and 1957 was the last time a full fixture list was played. Very few people had a television, so football was the main entertainment for the day.

WHY NOT? Find out how many football clubs use only their initials on their badge. Then create your own badge using just your initials.

VISIT The National Football Museum in Manchester and see an amazing collection of football shirts, memorabilia, and activities.

BLACK GOLD IN THE GRANITE CITY

The first North Sea oil was brought ashore to Aberdeen in 1969.

The discovery of a giant gas field in the Netherlands a decade earlier had raised hopes of finding oil under the North Sea. After years of exploration, a pocket was found about 130 miles east of Aberdeen.

Secrecy was vital while drilling. Daily radio messages back to shore gave well depths based on American college football teams. A sample, in a pickle jar, was sent onshore for testing. It was declared to be oil.

The multi-billion dollar industry brought wealth to the British economy through taxation. The traditional fishing city of Aberdeen was transformed into 'the oil capital of Europe'. The harbour became lined with offshore supply vessels: the airport hosted 400,000 helicopter flights offshore a year: the skyline was filled with the European headquarters of the world's biggest oil companies. There are still 20 billion barrels of oil waiting to be extracted while 90% of Scotland's electricity now comes from 'green' energy sources.

In 1972 Aberdeen FC adopted a modern badge designed by Aberdonian, Donald Addison, in keeping with the new international image of the city. The letter 'A' was made up of a goal mouth and a football. There have been a few changes over the years but the basic idea remains the same.

ABERDEEN FC
Twenty years after the event Aberdeen added two stars to their badge to mark the two European trophies the team under Alex Ferguson picked up in one remarkable season, the European Cup Winners' Cup and the European Super Cup of 1983.

DID YOU KNOW? With helicopters buzzing as they take and return men offshore, Aberdeen Airport is the world's busiest civilian heliport.

WHY NOT? Trace the 30 places named Aberdeen throughout the world. Towns and cities called Aberdeen can be found in Canada, Australia, Hong Kong and South Africa.

VISIT Follow the story of North Sea Oil at the Aberdeen Maritime Museum. It may be joined by Aberdeen FC's new museum if plans for a move to a new stadium go ahead.

A SECOND INDUSTRIAL REVOLUTION

Margaret Thatcher came to power in 1979. She wanted to create a new industrial revolution moving away from the old industries of coal mining, fishing and heavy engineering to the new industries of financial services and advanced technology.

Clubs have taken different approaches to their badges if the industry it refers to is no longer, either deciding to keep the reference to a proud past or to adopt a completely different approach.

In the 1950s Grimsby on England's East Coast was the world's largest fishing port. Now there are fewer than 20 fishing boats. Grimsby FC still boasts a trawler and three fish on its badge.

Sunderland also used to have a ship on its badge. This symbolised shipbuilding rather than fishing. The city was the world's largest shipbuilding town, with 400 shipyards registered in its history.

Clydebank downriver from Glasgow was a village until shipbuilding arrived in 1870. A decade later the world's largest sewing machine factory, Singer, arrived. Although both are long closed, Clydebank FC decided to keep them in two quarters of its shield.

SUNDERLAND FC
The ship badge was in use until the club moved to a new stadium in 1997.

CLYDEBANK
The town coat of arms of Clydebank contains a sewing machine. The football club uses a simplified version with a cog wheel rather than a sewing machine.

DID YOU KNOW? The coastline of mainland Britain is nearly 18,000 km (11,000 miles) long.

WHY NOT? Find the football team in Scotland that have a fish on their badge.

VISIT The Grimsby Fishing Heritage Centre gives a good impression of what a fishing family's life was like on land and at sea.

NO EXTRA TIME FOR COAL

Cowdenbeath Football Club was built on coal. It was located in a West Fife coalfield town in Scotland. Coal had been extracted from pits with names like Ding Dong, Dryhouse and Drum Sink for over a century.

Miners had a long tradition of poor working conditions, left wing politics, being active in the Union and of striking for their rights. Many families lived in overcrowded conditions. For boys, football was the only escape from following their father down the mines.

The 1984-5 miners' strike was long and bitter, dividing families between those who wanted to work and those who joined the picket line to stop them. The men went back after a year having failed to halt the programme of pit closures.

The strike proved the death knell for Cowdenbeath as for similar communities throughout Britain. Many depended on coal for work so closing the mine killed the community. Cowdenbeath's was a typical story with women running soup kitchens and children gathering coal from the waste tips.

To remember the heritage of a club which was formed by miners and whose team nickname used to be The Miners, Cowdenbeath FC has a winding wheel and two crossed picks and shovels on its badge. The winding wheel raised and lowered the rope-drawn cages that carried miners down to the coal seam where they used picks to cut the coal.

COWDENBEATH FC
The club badge was updated in 2015 to include two crossed picks and shovels and a winding wheel highlighting the local mining industry.

SUNDERLAND AFC
Sunderland is another club with strong links to coal. Its new stadium was built on a former coal mine and was named The Stadium of Light after the Davy lamp that miners used to see safely in the dark. Like Cowdenbeath, the badge features a winding wheel. Can you spot it?

DID YOU KNOW? Three of the greatest managers in football history – Matt Busby, Bill Shankly and John (Jock) Stein – were all coal miners in their teens.

WHY NOT? See how many clubs you can find that have links with coal. What about Easington Colliery AFC, Sherwood Colliery FC, Harworth Colliery FC, Coventry Colliery FC, North Gawber Colliery FC, Shotton Colliery FC, Pontefract Collieries FC or South Kirkby Colliery FC? Atherton Collieries FC was established in 1916 by miners from the six pits in Atherton Urban District with the aim of raising money for locals involved in the war effort.

VISIT Your nearest coal mining museum to discover the story of coal. There are national museums outside Edinburgh and between Wakefield and Huddersfield and lots of other experiences featuring mining everything from tin to lead.

1989
BACK OF THE NET!

How would you survive without streaming a video, keeping in touch with friends virtually or following your favourite team on social media? The world has changed out of all recognition in the last half century thanks to the computer revolution.

Like hashtag and email, www is now part of our daily language. The World Wide Web was only invented in 1989 by English computer scientist, Sir Tim Berners Lee. As a student he built his first computer out of an old TV. While working at CERN, Europe's major physics laboratory, he came up with a way of sharing the same information automatically among millions of users. To spread the information quickly CERN made sure that developers could use the web software free of charge. Since then Sir Tim has worked tirelessly to keep the web free, open to all, not subject to censorship. Today 59% of the world's population is active on the web.

One of the more unexpected effects of the web is Hashtag United FC which brings real football to the virtual world. Founded by YouTube football celebrity, Spencer Owen, in 2016, it plays its football in its Essex stadium. Games were initially filmed for the YouTube channel but since the 2018/19 season the team has grown massively, is part of the Football League pyramid and plays in the FA Cup.

HASHTAG UNITED FC
One of the most unusual names, and badges of any football club, ever!

DID YOU KNOW? Cristiano Ronaldo has 270 million followers on Instagram, a world record for a sportsman.

WHY NOT? Some football clubs explain the history of their badge on their website, and what it means. But many don't. Does yours?

VISIT The National Museum of Computing at Bletchley Park or London's Science Museum to explore the byways of the history of computing and see some remarkable machines.

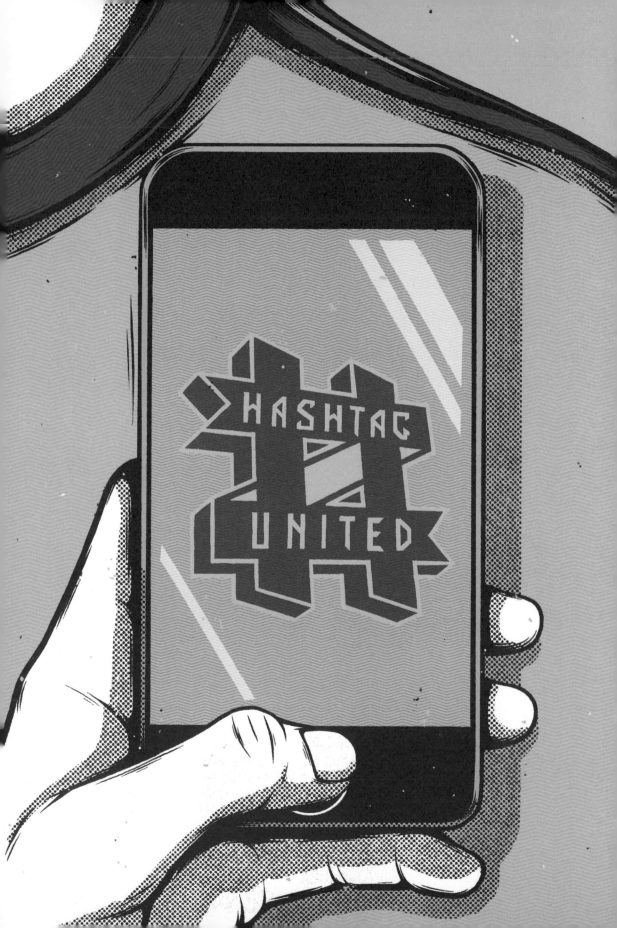

TIME ADDED ON

IT'S NOT ABOUT THE NAME ON THE BACK OF THE JERSEY. IT'S ABOUT THE BADGE ON THE FRONT.

DAVID BECKHAM
(DID YOU KNOW THAT IN THE EARLY DAYS OF HIS CAREER 'BECKS' PLAYED FOR PRESTON NORTH END FC?)

FOOTBALL TIME

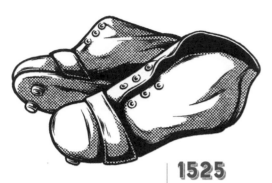

1667

The annual Shrovetide Football which is still celebrated in Ashbourne, Derbyshire was typical of games played up and down the country for centuries before – wild, violent and with few rules other than to deliver the ball, which might be a pig's bladder, into goal. Game play was a bit like a rugby scrum with around 5,000 people joining in as players or spectators from rival towns.

Buckinghamshire housewives in Olney had been tossing pancakes as they raced, for generations by now. The story goes that when a local woman heard the church bell ringing for confession on Shrove Tuesday, 1445 while she was making pancakes, she ran to church, frying pan in hand.

1525

The first pair of football boots were made for King Henry VIII.

Henry VIII celebrated the defeat and capture of his enemy the French king with a gargantuan meal. He loved feasts which often ran to 14 courses. Is it surprising that he weighed 28 stone (178 kgs) when he died?

1314

The first written mention of football was in a document issued by the Lord Mayor of London on behalf of King Edward II banning the playing of the game to keep public order.

The Battle of Bannockburn – one of the few times that the Scots thrashed the English.

1540s

Someone kicked the ball too high and it lodged in the rafters of a room in Stirling Castle. It is the world's oldest surviving football.

It is not known who kicked that famous football but Mary Queen of Scots who at one time lived in the Castle was the 16th century's most famous football spectator.

1863

The first Football Association was set up at a meeting in a London tavern. Its rules marked the separation of association and rugby football. Carrying the ball with the hands was banned and the standard size and weight of the ball was agreed. The first football match under the new rules was played between Barnes FC and Richmond FC. It ended in a goal-less draw.

///////////////////////////////

The first stretch of the London Underground, from Paddington to Farringdon Street, opens to the public.

1872

The first badges to appear on football shirts date back to the start of the official international between the two countries when England sported the now famous three lions and Scotland, the lion rampant. The latter were embroidered by the sister of one of the players. Hosted in Glasgow, the match resulted in a goal-less draw.

///////////////////////////////

Voting by secret ballot is introduced making elections much less at risk of corruption.

1856

The oldest surviving rules of football were published. Public schools like Eton and Rugby and Universities started to adopt ball games as character building from the early 19th century.

///////////////////////////////

Cambridge won the very first boat race between Oxford and Cambridge Universities.

1824

The world's first football club, established by a student in Edinburgh, was rather unimaginatively called The Foot-ball Club. It survived until 1841.

///////////////////////////////

Edinburgh Town Council set up Britain's first public fire brigade a month before 400 people were made homeless by the Great Fire of Edinburgh.

1857

Non-league Sheffield FC is the world's oldest surviving football club. It still plays the first known local derby with Hallam FC.

///////////////////////////////

Queen Victoria had a busy year. She gave her husband the title of Prince Consort, awarded the first 60 Victoria Crosses for bravery on the battlefield and chose Ottawa as the capital of Canada.

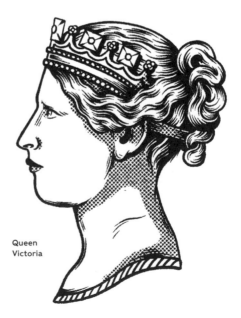

Queen Victoria

1878

Which was the first club to sport badges - Aston Villa or Glasgow's Queen's Park? The Scottish lion appeared on Villa shirts in 1878 but they may have been bought from Queen's Park whose players made up the whole of the Scottish team at the first England v Scotland international. In the same year the world's first football game lit by floodlights was played in Sheffield. It did away with the need to wear some distinguishing mark on a player's jersey to tell him from an opponent in the dark.

////////////////////////////

Is that Your Majesty?' Alexander Graham Bell demonstrated his telephone to Queen Victoria.

Buffalo Bill

1887

Aston Villa may have been the first team to wear a badge in a cup final as six players had the city of Birmingham's crest on their jerseys. The crest was the badge of the Birmingham & District Football Association. It had been awarded to players selected for a match against the Sheffield Association a month earlier.

////////////////////////////

Buffalo Bill's Wild West show opened in London. Queen Victoria saw it and was amused. It toured to Manchester and Birmingham, clocking up over 300 performances before returning to the USA.

1894

The Dick Kerr Ladies, a works team from Preston, was set up. Although women were playing organised football by now, this was the most famous team who played internationally. The FA banned women from playing in its grounds in 1921 as being a game 'quite unsuitable for females', only organising women's football from the 1990s.

////////////////////////////

Michael Marks and Thomas Spencer got together to open their first store in Manchester.

Fergus Sutor

1885

The game turned professional. The Football Association allowed clubs to pay their footballers a wage as long as they had been born or lived within six miles of the ground for two years. While playing for Blackburn Rovers, Fergus Sutor became the first footballer to be paid. He was one of a select band, known as 'the Scotch Professors' who introduced English clubs to the fast moving Scottish version of the game. In the same year, Arbroath FC defeated Aberdeen's Bon Accord 36-0, a world record that still stands.

////////////////////////////

Holidaymakers took a trip on the Blackpool trams, the first to be powered by electricity.

1888

The first Football League was established with 12 members. Preston North End won the first league title, as well as the FA Cup.

//

Jack the Ripper began his murderous spree in the East End of London.

Lilly Parr of
Dick Kerr
Ladies

1950

Having joined FIFA, England played its first World Cup. It was defeated 1-0 by the United States at the group stage. England had to wait until 1966 to claim the silverware. This nearly did not happen as the trophy was stolen before the event but a dog called Pickles retrieved it in the nick of time.

////////////////////////////////////

A pilot episode of the serial, *The Archers*, about a farming community, was played on BBC Radio. It is still running and is now studied at GCSE.

2010

Carlos Tevez became the first player to earn £1 million per month, when he signed for Manchester City.

////////////////////////////////////

People got snapping on their phones as Instagram was launched.

1902

Ghanaian Arthur Wharton was the world's first professional black player. He played his last game in goal for Stockport County.

//

There was a craze for sending and collecting postcards after the Royal Mail accepted cards with a picture on the front and a message on the back.

Arthur Wharton

1992

Top English clubs broke away from the Football League to form the FA Premier League largely to benefit from valuable TV rights. Today there are 20 clubs in the Premier, the world's most watched football league.

////////////////////////////////////

Not a good year for HM Queen Elizabeth II who declared it her 'annus horribilis'. Three of her four children's marriages failed and her home at Windsor Castle suffered a severe fire.

2020

The top league games continued without their fans thanks to the coronavirus restrictions.

////////////////////////////////////

People learned the new language of lock-down and social distancing.

THE BEST YOUNG FOOTBALL BADGE DESIGNERS IN BRITAIN!

We'd like to thank all the young fans who sent in their wonderful badge designs. These are our favourites.

P (age 5)

A.N (age 10)

R (age 10)

V.T (age 4)

H.C (age 11)

M (age 11)

N.V (age 10)

E (age 7)

R (age 11)

S (age 10)

K.M (age 9)

A.Y (age 10)

A

R.M (age 7)

S.B (year 2)

J.D (year 2)

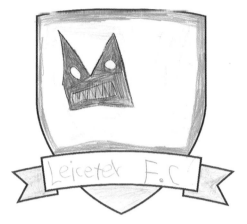

D.M (year 2)

R.W (year 2)

Y.M (year 2)

Y.M (year 2)

H.S (year 2)

U.P (age 10)

C.K.B (age 10)

A.M (age 10)

H.T (age 10)

T.W (age 9)

LANGHO FC

T.B (age 7)

I. W (age 13)

R.R (age 15)

C.M (age 11)

G.D (age 15)

A.D (age 12)

I.J-C (age 10)

L.J-C (age 7)

CREATE YOUR OWN BADGE

Why not design a football club badge yourself? It could be for the team you support or play for or for a new club that you have just invented.

Think about what you want the badge to say about the club. Perhaps you can choose a symbol associated with its location or something from history. What makes the club special?

Will the badge feature animals or mythical creatures?

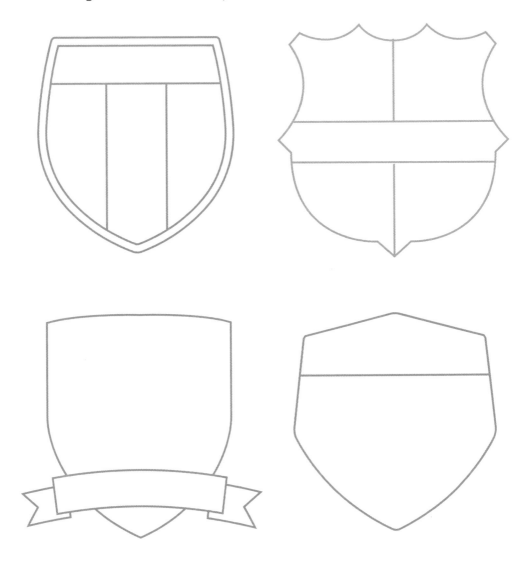

CREATE YOUR OWN BADGE

BIZARRE!!!

As well as badges, most football clubs express their personalities through mascots, mottoes and nicknames. Mottoes, often in Latin, follow the tradition of coats of arms, many of which had a few words, usually printed on a ribbon at the foot. Some mascots, the characters who run on to the pitch before the start of a game and fundraise for charity, are obvious. West Ham has Hammerhead and Liverpool has a Liver Bird, albeit a rather strange looking one. Some are more unusual.

WORLD CUP WILLIE

Inspired by the mascot, World Cup Willie, the chairman of Bradford City came up with the City Gent, modelled on himself. The City Gent was round, wore a club strip and a bowler hat and carried a briefcase. He was later revived as a mascot as the fans missed him until replaced by Billy Bantam echoing one of the fans' nicknames.

GUNNERSAURUS

During the 93/94 season Arsenal's Junior Gunners ran a contest to design a new mascot. The winning name and design was that of 11-year-old Peter Lovell whose Gunnersaurus Rex became a firm favourite with fans, even making a surprise appearance at Peter's wedding, many years later.

CRUSTY THE PIE

Wigan Athletic's new mascot is Crusty the Pie, a reference to one of the region's favourite foods. The club is known as Latic as is Oldham Athletic. Latic is simply shorthand for Athletic.

THE BULLS

Introduced in the 1920s, the first club mascots were live animals like horses. As late as the 1980s, it was one of the jobs of Hereford United's chairman to clean up after the club mascot, a Herefordshire bull.

MONKEY HANGERS

The name of Hartlepool United's official mascot is H'Angus the Monkey, a twist on the fact that people from the town are sometimes known as 'monkey hangers'. This in turn is based on on a popular legend in the town dating back to Napoleonic times when a shipwrecked monkey was hanged because people believed him to be a French spy.

THE QUAKERS

Darlington FC is known as the Quakers and a Quaker features on their badge. This is because local Quaker families were very active in supporting the town's prosperity and promoted the world's first railway.

PANDAMONIUM

Ayr United must have one of the most unusual names for its mascot, Pandamonium, sometimes shortened to Panda. This cuddly panda even runs in the Mascot Grand National. Why a panda for a team whose home ground is nowhere near a zoo? The team's strip used to be black and white.

LOGGERHEADS

Shrewsbury Town FC has played around with loggerheads as the nickname for their fans and also on their badge for many years. The loggerhead is a legendary heraldic beast like a leopard first used on the town coat of arms in the 17th century. It has had several narrow escapes. The latest design of the badge had the loggerheads looking like lions. The fans soon threw it out.

THE BLUE BRAZIL

Cowdenbeath is known as the Blue Brazil. No-one knows the origin of one of the best nicknames in football history but fans have plenty of theories. They range from the obvious 'because the strip is blue' to the fanciful tale about how local miners dug a shaft all the way to Brazil and returned with three football players.

THE ADDICKS

The nickname that is most associated with Charlton Athletic fans is the Addicks. The club believes that the name comes from a local fishmonger who supplied both sides with haddock and chips after a game. In South London dialect, haddock became Addick.

THE TANGERINES

Dundee United fans rejoice in three nicknames – the Arabs, the Tangerines and the Terrors.

BLACK CATS

Sunderland AFC is known as the Black Cats. No-one really knows why. One theory is that it was called after a local gun battery, built to defend the coast against possible attack by Napoleon. It was called the Black Cat Battery after a soldier reported hearing a cat crying in it one night. Another theory is that it refers to the cat that a supporter smuggled into Wembley for the 1937 FA Cup Final against Preston North End. It certainly brought Sunderland luck: they won 3-1.

THE POSH

Peterborough United's nickname dates back to the era of a predecessor club. Its player-manager announced in 1924 that he was looking for 'Posh players for a Posh team' to compete in the Northamptonshire League. The name Posh stuck.

ERIN GO BRACH

Edinburgh's Hibernian FC was the only team outside Ireland to boast a motto in Irish. It was Erin Go Brach meaning Ireland Forever. The club which had been founded in 1875 to serve the growing Irish community dropped the motto in 1955 to appeal to a wider audience.

YOU'LL NEVER WALK ALONE

Liverpool FC must be the only club to adopt the title of a pop song as its motto. 'You'll Never Walk Alone' was written by Rodgers & Hammerstein for their 1945 musical, *Carousel*. The song was covered by the Liverpool group Gerry and the Pacemakers in 1963 and fans have been singing the song ever since.

LUDERE CAUSA LUDENDI

Possibly the earliest motto in football history, dreamed up in 1867, is Glasgow Queens Park's 'Ludere causa ludendi', to play for the sake of playing. In 2019 Scotland's oldest club voted to go professional after 152 years as amateurs.

NOWT CAPS CONISTON

Tiny Coniston AFC in the Lake District has possibly the only motto in a local dialect, 'Nowt caps Coniston', roughly translated as 'You can't beat Coniston'.

CONSILIO ET ANIMIS

When redesigning its badge in 2016, Sheffield Wednesday reintroduced its Latin motto – Consilio et Animis, By wisdom and courage. This had some Latin lovers scurrying for their dictionaries. Where did it come from, what was the source, had the club made it up?

NIL SATIS NISI OPTIMUM

Nil satis nisi optimum, only the best is good enough, has traditionally been Everton's motto since 1938. More than once the club has tried to drop it when updating its badge but fans are very attached to it. Within days of the latest attempt in 2013, 22,000 fans signed an online campaign rejecting the new badge and took to social media to express their views. The old motto was restored.

On which badge does a bee meet a submarine?

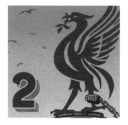

What is the name of Liverpool's most famous bird?

Where was Doggerland?

WHAT DO YOU KNOW?

You will find all the answers in the book.

What ship features on three club badges?

Who said 'Veni, vidi, vici'?

Why are there several statues of Walter Tull?

What was flown to land in a pickle jar?

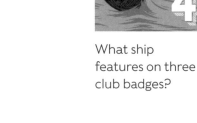

What battle was lost when a soldier stood on a prickly plant in his bare feet?

What is the name of the small fierce dragon with two legs, two wings and a curly tail?

Which is taller: the Blackpool Tower or the Eiffel Tower?

11. Who are Tottenham Hotspur named after?

12. If you wore a red rose, which side did you support in a family war?

13. What bird did the Strangers breed?

14. What is Burton-on-Trent famous for?

15. What was Earl Russell so desperate to acquire that he queued all night?

16. Which football club has a rebus, a sort of visual pun, as its badge?

17. What do Bristol City fans have in common with early postmen?

18. Where was Britain's first New Town?

19. What game did Roman soldiers play that was a bit like football?

20. What aircraft that featured on a football badge help to win the Second World War?

1. Barrow AFC. 2. The Liver Bird which appears on Liverpool FC's badge 3. A land bridge to Europe which was flooded by the North Sea 4. The *Mayflower* 5. A Roman, their leader Julius Caesar. 6. The professional footballer was the first black British officer in the First World War 7. North Sea oil 8. The Battle of Largs 9. A wyvern 10. The Eiffel Tower in Paris 11. Harry Hotspur Percy, the greatest warrior of the 14th century 12. The House of Lancaster in the Wars of the Roses 13. The Norwich canary 14. Brewing beer 15. A1, the first car number plate 16. Oxford United FC 17. Both were nicknamed Robins 18. Stevenage in Hertfordshire 19. Harpastum 20. The Spitfire.

I-SPY FC

There are lots of landmarks and buildings featured on football club badges that you can spot around the country.

This is our starting XI to kick off with.

1
The Imp, Lincoln cathedral
Lincoln City FC

2
Wallace Monument, Stirling
Stirling Albion FC

3
Prince Rupert's Tower, Everton, Liverpool
Everton FC

4
Martello Tower, Eastbourne, Sussex
Eastbourne Borough FC

5
Norwich Castle, Norfolk
Norwich City FC

6
Heart of Midlothian, Edinburgh
Hearts FC

7
Church of St Mary and All Saints, Chesterfield
Chesterfield FC

8
The Falkirk Steeple, Falkirk
Falkirk FC

9
Sherwood Forest, Nottingham
Nottingham Forest FC

10
Haverfordwest Castle
Haverfordwest County FC

11
Windsor Castle Berkshire, England
Linfield FC
(Belfast, N.Ireland)

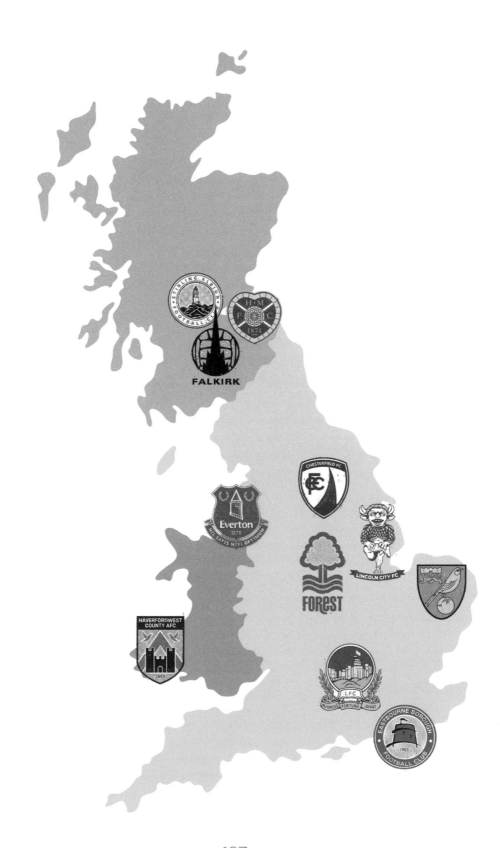

INDEX

W

ACKNOWLEDGEMENTS

Thanks to the clubs who participated with this book and its predecessor, *The Beautiful Badge.*

Many thanks to all the young people that got creative and sent in some wonderful football badge designs.

A special thanks to all the pupils and staff at the The Mead Educational Trust, Leicester, especially Willowbrook Mead Primary Academy and Abbey Mead Primary Academy.

ABOUT THE AUTHORS

Martyn Routledge

Martyn is a designer and creative director, who founded his own branding and marketing agency (mr.creative) in 2017.

He has created many exhibitions and books including the 2012 publication *Olympics: A Snapshot History of the Olympic Games.*

It was Martyn's University dissertation that would eventually grow into *The Beautiful Badge.*

It was whilst writing *The Beautiful Badge* that Martyn hit on the idea of using football (and football club badges), as the hook to get young people to think about the wider historical context.

www.mrcreativestudio.co.uk

Elspeth Wills

A graduate of St Andrews University with a degree in modern history. Elspeth did a year towards a PhD on the Great Exhibition at Birkbeck College, University of London before she decided to live in the real world and get a job.

Her day job for the last 20 years has been as a researcher/interpreter/ writer working with graphic designers and landscape architects on projects like Belfast's Titanic and country houses for the National Trust.

In her spare time she has written over a dozen books, all for commercial publishers. She has collaborated with Martyn on several exhibitions and books, including *The Beautiful Badge.*

Adam Forster

Adam graduated from Plymouth University with a BA(Hons) in Illustration in 2016.

An exciting young talent, he has produced work for several football publications.

www.adamforsterillustration.com

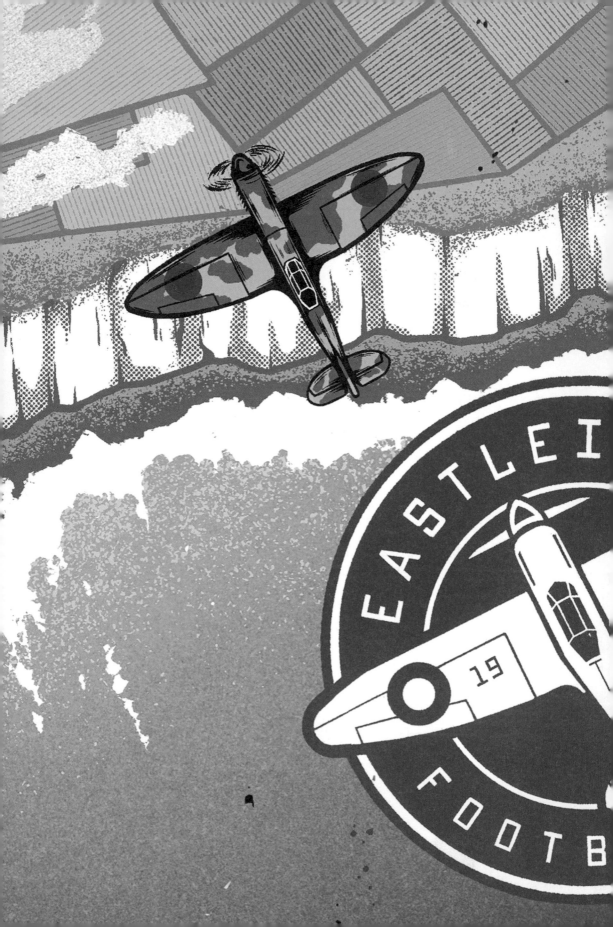